# HOCKEY IN
# BROOME COUNTY

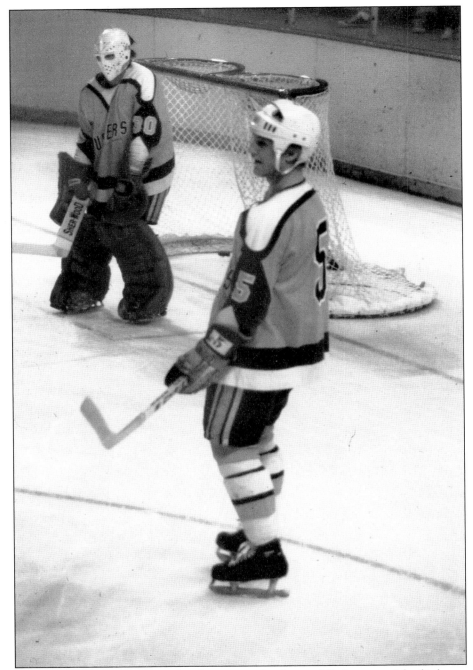

Rod Bloomfield was the first great fan favorite at the Arena. His image as "the little guy that everyone picked on" belied the fact that he was a prolific scorer. In that inaugural year of 1973–1974, he tallied 119 points and led the league with 72 assists and 16 power-play goals. Rod was tops for the Dusters in every category except games played and, of course, goaltending. As if that was not enough, during the filming of the movie *Slap Shot*, Rod was chosen to double for Paul Newman in the on-ice sequences. Being a "little guy" paid off again.

# HOCKEY IN BROOME COUNTY

Marvin A. Cohen and Michael J. McCann

ARCADIA
PUBLISHING

Published by Arcadia Publishing
Charleston, South Carolina

Printed in the United States

Library of Congress Catalog Card Number: 2005926762

For all general information contact Arcadia Publishing at:
Telephone 843-853-2070
Fax 843-853-0044
E-mail sales@arcadiapublishing.com
For customer service and orders:
Toll-Free 1-888-313-2665

Visit us on the Internet at www.arcadiapublishing.com

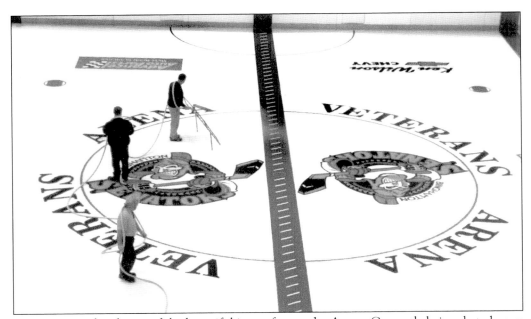

Here is an overhead view of the beautiful ice surface at the Arena. Currently being skated upon by the Binghamton Senators, it has also been home to the Broome Dusters, the Binghamton Whalers, the Binghamton Rangers, and the B.C. Icemen.

# CONTENTS

# ACKNOWLEDGMENTS

This book could not have been written without the gracious assistance of Scott Allegrino; Charles Brown and the Broome County Historical Society; Mike Callahan; Bob Carr; Joseph McCann; Susan McCann; Dominic Nicoletta; John Nuzzela; Brendan O'Reilly; Hans Petersen; Mike Prozeralik; Lisa Shattuck; Cliff Signor; Pete Sobiech; Andy Strong; Joe Strong; Kim Trevett; Dave Tripicco; Georgia Vieira; Mark Wheeler; Grady Whittenburg; and Pete Zalaffi. Special thanks must also be given to Rich Rea and Gene Card for their generosity in providing a multitude of Broome Dusters pictures; Tom Mitchell, Binghamton Senators general manager, for his unstinting generosity in providing anything the authors needed to create the book; the great folks at Just Sports Photography: Nancy Attrill, Bill Duh, and Tom Ryder; and last, but certainly not least, Cay Cohen for her editorial wizardry and computer skills that pulled it all together. Thank you all!

# INTRODUCTION

The long-awaited Broome County Veterans Memorial Arena ("the Arena") opened on August 29, 1973. An exhibition hockey game was played a month later before 4,620 curious spectators to officially introduce the sport to the area. Then came the regular season, featuring the newly formed Broome Dusters of the North American Hockey League. After just five games, a love affair was born between the team and its fans that surprised everyone. The Dusters were soon outdrawing more-established teams in their league, even those with larger arenas. For three seasons, hockey fans also supported a New York–Penn Major Junior Hockey League team, the Binghamton Barons, who skated at the Chenango Ice Rink, until their league disbanded in 1979.

Players like Rod Bloomfield, Ken Holland, and Randy MacGregor became household names as the Broome Dusters entertained their supporters through the club's final season of 1979–1980. The Dusters were followed by the Binghamton Whalers, the Binghamton Rangers, the B.C. Icemen, and currently, the Binghamton Senators. Many fine players have left the Arena and gone on to the National Hockey League, after contributing richly to local hockey lore. Most recently, in 2004–2005, due to a lost year by the National Hockey League, Jason Spezza returned to Binghamton for a classic season in which he exceeded 100 points scored in goals and assists. For local hockey buffs, that achievement must have brought back memories of the initial season of professional hockey in the area, when Rod Bloomfield tallied 119 points for the Dusters in 1973–1974.

There have been many great moments between the accomplishments of Bloomfield and Spezza. They are all here for your enjoyment, in more than 200 pictures and captions, which dramatically capture the players and teams that have brought so much excitement to the area's loyal fans.

A crowd of 4,620 fans attended the opening ceremonies and exhibition game on September 29, 1973. The event was entitled "Icebreaker" for obvious reasons. The festivities began with the stars of the Ice Capades skating out to cut the ribbon, signifying the official opening of the Arena. It took five games for hockey to excite the local fans, but by season's end the attendance numbers at the Arena were well above what had been anticipated.

# ONE

# *Broome Dusters*
## *1973–1980*

After the dedicated work of many local supporters and the expenditure of $7.5 million, the Broome County Veterans Memorial Arena opened on August 29, 1973. Win Warner, for one, had been pushing for construction of an arena for decades. Warner was an off-ice official who assisted the new owners with start-up activities. Stuart McCarty (shown here), that year's local United Way chairman, was among the many fans who could now enjoy the opportunity to skate at the new facility.

The 1973–1974 season, the Broome Dusters' first in the North American Hockey League (NAHL), saw them fail in a valiant effort to reach the playoffs. However, while they did not succeed on the ice, they clearly won the hearts of area fans. Professional hockey at the Arena succeeded beyond expectations in terms of fan support. Why did this happen? The turning point may have been the Dusters' huge win on November 11, when they shocked a Syracuse "powerhouse" that had been the previous year's Eastern League champions, defeating them by a score of 10-4. Soon fans devoted their energies to hoisting signs, such as the one below, rather than throwing debris, as they had done previously. (In fact, spectators had made it common practice to hurl the plastic armrests from their seats onto the ice—that is, until one of the armrests hit the head of Dusters' captain Bob Channell.)

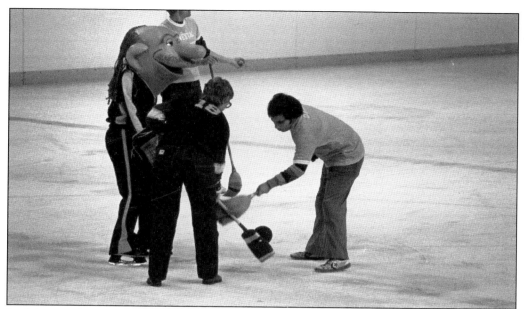

In this rare photograph, the Broome Dusters' mascot, Thor (based on a character in the B.C. comic strip, drawn by cartoonist Johnny Hart), plays broom-ball with a pair of enthusiastic fans. Hart, who was born in Broome County (Endicott), also created the logo for both the Dusters and the B.C. Icemen.

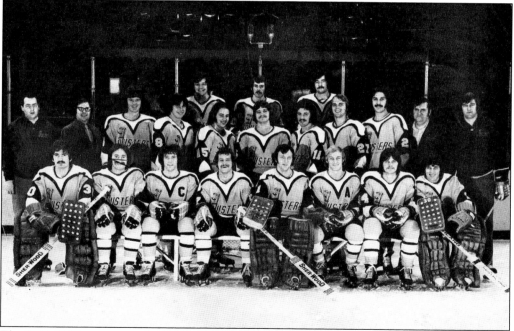

The 1973–1974 season was the first for the Broome Dusters hockey club, and they were in the hunt for a playoff spot right up to the final week of play. That was an amazing achievement considering that only 7 of the 46 who wore the gold-brown-and-white uniform had been there for the entire season. Clearly, much of the credit for that success belonged to coach Wayne Kitchingman.

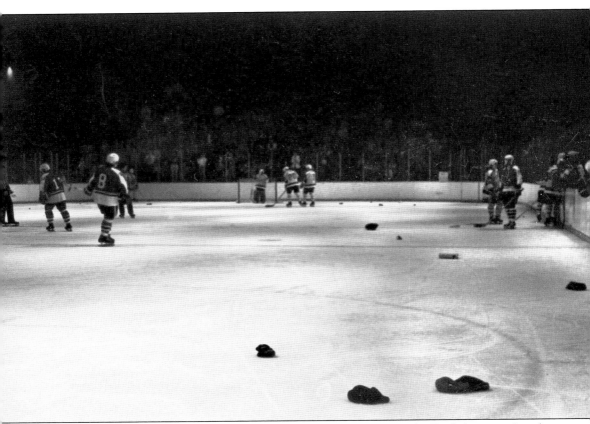

We have all heard the theory that baseball may have evolved from the English sport of cricket. It makes some sense, since both games utilize a bat and a ball. But how many sports fans know of a link between cricket and hockey? The connection comes from the term "hat trick," which originated when the ordinarily reserved English fans tossed their hats after the knocking down of three consecutive wickets. When a hockey player scored three goals in a game, appreciative spectators on this side of the Atlantic threw their hats onto the ice. Binghamton fans continued this tradition, as illustrated in this photograph from a Dusters home game.

Norm Martel played all 74 games for the Dusters during that first season at the Arena (1973–1974). He scored 7 goals and had 27 assists. His seven goals tied him with Paul Brown for most goals scored by a Dusters defenseman. The 27 assists is a team record for defensemen that was never broken.

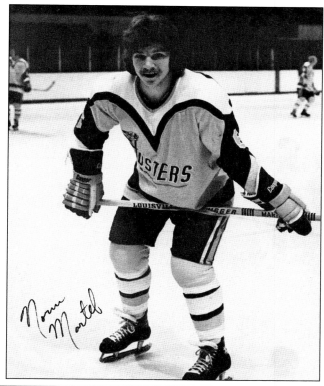

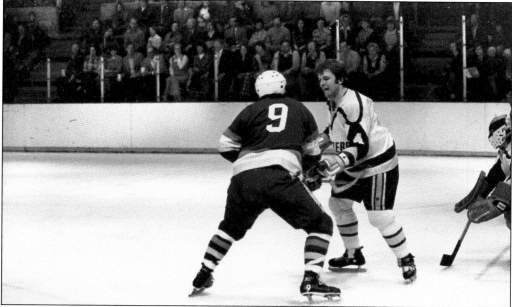

Not to be outdone by Norm Martel, who had tied him for the Dusters' record of seven goals by a defenseman in that first season, Paul Brown set his own record. On January 30, in a game against Long Island, he tallied two goals in the same contest. To make the achievement even sweeter, he did it in front of an appreciative home crowd at the Arena.

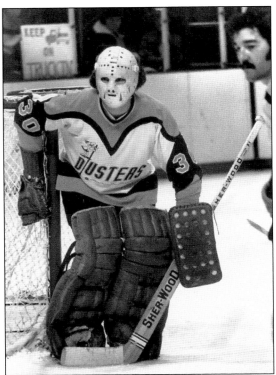

Roger Kosar appeared in goal for the Dusters in 1973–1974. Playing in more games than the other five goalies carried by the team combined, Kosar set club records for the longest shutout sequence (62 minutes, 45 seconds) and longest unbeaten streak (four games—three wins and a tie).

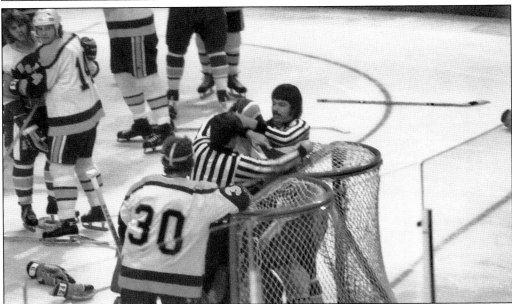

In that first year (1973–1974), Dusters goaltender Roger Kosar also set NAHL records for games and minutes played by a goalie. Having all that ice time meant Kosar (No. 30) witnessed quite a few fights. His relaxed approach to this fracas is revealed by his casual elbow on the net, as he waits for the officials to subdue an opposing player. A teammate (No. 14) adds some restraint to the situation.

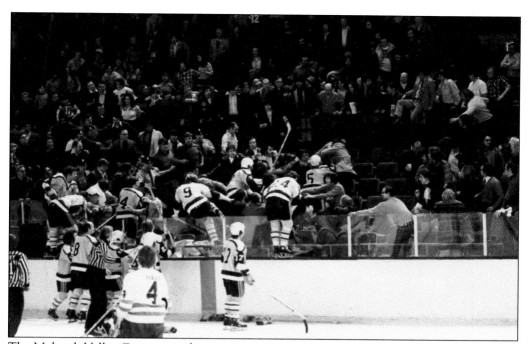

The Mohawk Valley Comets are the opponents and this time the fighting has spread into the seats. Clearly visible are (No. 5) Rod Bloomfield, who was usually the first one to get to the action; (No. 24) Neil Claremont, halfway there; (No. 9) Ken Davidson, already over the glass; and a number of other Dusters getting ready to help. Shown in the photograph to the right is the general manager of the Comets, pointing out the culprits to the Dusters' general manager, Ron Orr (right). Ron is the brother of hockey legend Bobby Orr, the great Boston Bruins star.

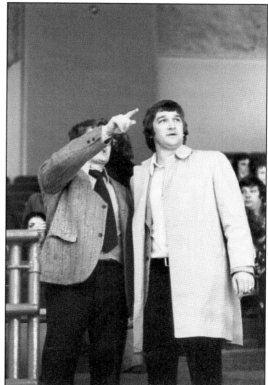

At the close of the 2003–2004 National Hockey League (NHL) regular season, Ken Holland, the general manager of the Detroit Red Wings, could feel gratified at the way his club had performed, as his squad easily won the Central Division of the Western Conference. Twenty-seven years earlier, Ken Holland had been a rookie goaltender for the Broome Dusters in the NAHL.

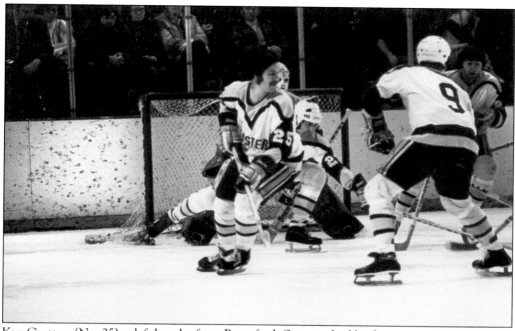

Ken Gratton (No. 25), a left-hander from Brantford, Ontario, had his best year with the Dusters in 1974–1975. The slick center tallied 27 goals and 40 assists that year. The total gave him family bragging rights since brother Bill, despite a fine season, trailed Ken in both categories.

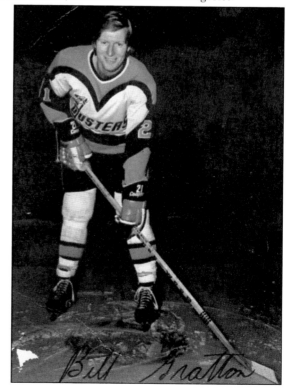

Bill Gratton, Ken's younger brother, was also a left-handed shooter. He played left wing for the Dusters, who purchased his contract from the Brantford Forresters. With Brantford, Bill was described as a six-foot three-inch tough guy, just what the Dusters needed. He arrived late in the 1973–1974 season, but the following year he accumulated 23 goals and 20 assists. Not bad for a tough guy.

17

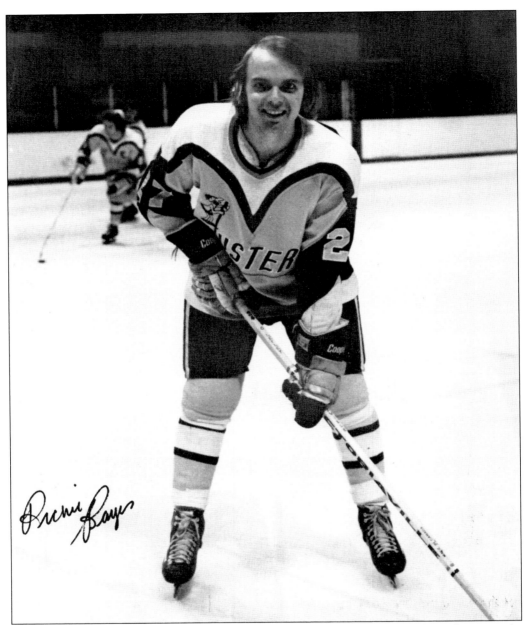

Richie Bayes holds the Dusters' opening-season record for the fastest goal from the start of a period. Against the Mohawk Valley Comets, on January 23, 1974, Bayes scored only 20 seconds into the third period. It was one of many goals that evening, as the Dusters romped by a score of 9-1. Bayes netted three of the Dusters' goals as he enjoyed his first hat trick of the year.

Every hockey club needs at least one "enforcer." Randy MacGregor, shown here leading the way, served effectively in that role for every Dusters team he played on and a few Whalers clubs too. His toughness was matched by his durability. MacGregor still holds the Dusters franchise records for games played, goals scored, assists, total points, and shots on goal.

Scott Hudson garnered 22 goals in the Dusters' inaugural season. His most spectacular one occurred on February 3, 1974, when he set a Dusters record for the fastest goal scored in overtime. His slap shot into the net came just 23 seconds into the overtime period and enabled the Dusters to defeat the Mohawk Valley Comets by a score of 5-4.

Frank Hamill came to the Dusters in 1973 from Laurentian University, where he had been a first-team All-Star selection. Hamill proved to be as good as his reputation: the slightly built (5 feet 8 inches, 165 pounds) right-winger netted 33 goals and compiled a team-leading 52 assists. What a way to start a professional career!

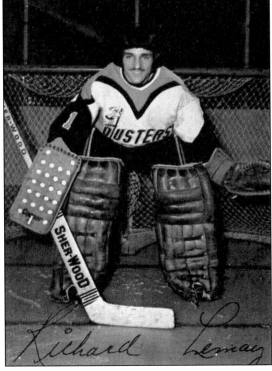

Rick Lemay was barely 20 when the 1973–1974 season began. Acknowledged early in the season to be the Dusters' best goaltender, he tore up his knee in November and was out for six weeks. That left Roger Kosar in the net for most of that season's games. In 1974–1975, the diminutive Lemay (5 feet 7 inches, 160 pounds) was back and healthy, with the best goals against average on the club.

Wayne Morusyk, a native of Elk Point, Alberta, played well enough in the Southern Hockey League with Greensboro, in 1973–1974, to be acquired by the Dusters for the following season. Along with Paul Brown, Dale McBain, Gary Jaquith, and Roy Carmichael, the addition of Morusyk gave the Dusters a formidable group of defensemen that measured up well against every other club in the league.

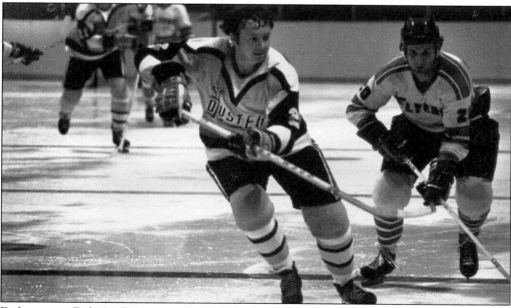

Defenseman Dale McBain spent half of the 1973–1974 season with Mohawk Valley before joining the Dusters. Known as Captain Crunch (and not because he liked the cereal), McBain had already suffered a broken ankle and thumb by the time he came to the Dusters. Then he lost most of the last half of the season with torn knee ligaments. However, in 1974–1975, healthy once again, McBain appeared in 52 games and contributed 18 assists and 2 goals.

## 1974-1975

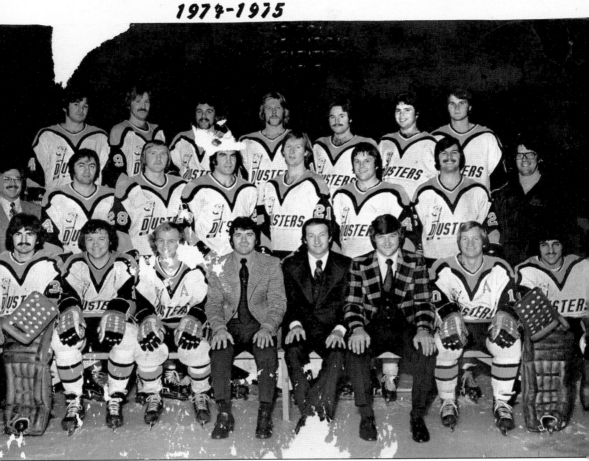

This time they made it. In only their second year of operation at the Arena, and with a new coach, Wayne Clairmont, the Dusters delighted their loyal fans by getting to the NAHL playoffs at the end of the 1974–1975 season. They then caused near hysteria by roaring past their first-round opponent, Mohawk Valley, four games to one. That got the Dusters to the Lockhart Cup finals. The bubble of euphoria burst in the next round, however, when the Johnstown Jets defeated them to take the Cup.

With a name that perhaps seems more appropriate to baseball than hockey, Walter Johnson spent the 1974–1975 season with the Dusters. After two seasons with the "Junior" Oshawa Generals, the native of Omaha, Nebraska, had spent most of the 1973–1974 campaign with the Dayton Gems of the International Hockey League (IHL). Walter had a fine year in Binghamton. In 69 games, he had 23 goals and 20 assists.

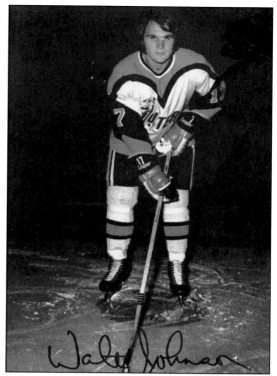

Yves Belanger, from Baie Comeau, Quebec, played for the Syracuse Blazers in the Eastern Hockey League (EHL), and was a goalie for the Jacksonville Barons in the American Hockey League (AHL). After splitting time with the St. Louis Blues and Atlanta Flames organizations in the NHL, Belanger's contract was purchased by the Boston Bruins. Eight games later, he was in Binghamton. Belanger had a lackluster 1973–1974 season. He gave up 95 goals in 25 games, and was released at season's end.

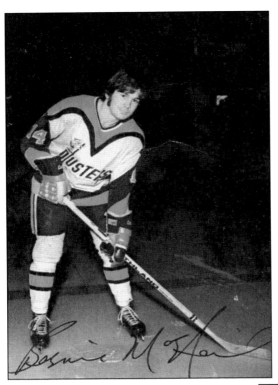

Bernie MacNeil paid his dues with the Espanola Eagles, Fort Wayne Komets, Greensboro Generals, and Los Angeles Sharks. The left-handed forward accumulated lots of points and penalty minutes wherever he played, and his year with the Dusters (1974–1975) was no exception. In 53 games, MacNeil piled up 12 goals, 20 assists, and as expected, 145 minutes in the penalty box.

Defenseman Paul Stewart played in 46 games for the Dusters in 1975–1976. Stewart tells the amusing story of responding to an invitation for a Boston Braves reunion, which turned out to be for the defunct Boston Braves baseball team, not his former hockey team. Even worse, the invitation was not for him, but for his father, who umpired in the 1948 World Series that the Braves won.

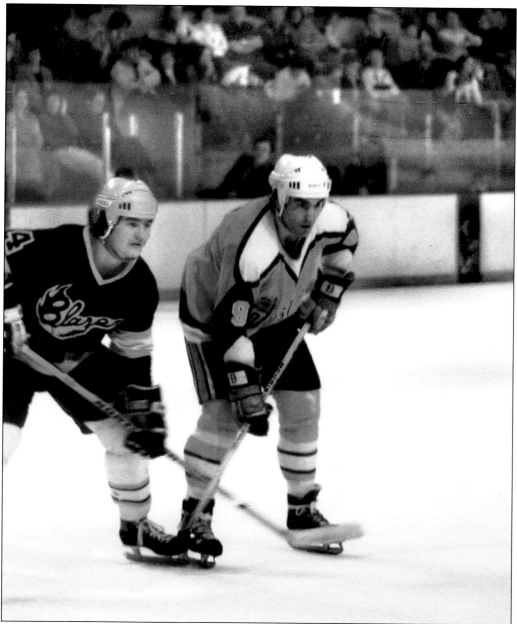

Defenseman Gary Jaquith, shown here awaiting a face-off, was a University of New Hampshire graduate who grew up in Massachusetts. In his first year with the Dusters, 1974–1975, he had 8 goals and 22 assists in 61 games. He also spent 109 minutes in the penalty box. Jaquith was even feistier the next season, when he spent 144 minutes off the ice at the request of the officials. Despite all that idle time, he contributed 25 points and added 2 more in the playoffs.

Pierre Laganiere spent three years with the Dusters (1976–1978). He quickly became a fan favorite in his first year, and no wonder. He tied for most games played (74); was second on the club in assists (79); was third in goals scored (48); and was tied for second-highest point total, with 127. Laganiere also excelled in the playoffs, with 9 goals and 7 assists in the 10 games played.

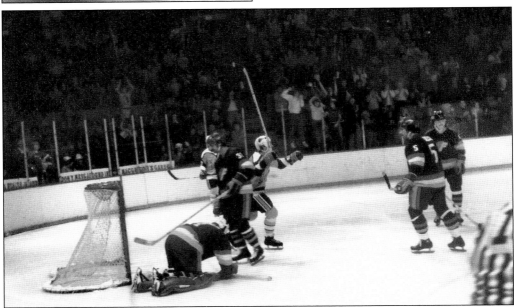

Broome Dusters' players piled up 982 points during the 1976–1977 NAHL season. While 619 of these points came from assists, there were 363 goals scored. Of the 363 points awarded for goals, three players alone—Rod Bloomfield (49 goals), Dave Staffen (87 goals), and Pierre Laganiere (48 goals)—accounted for half of them. The traditional raised stick indicates that one of those goals has just been added to the total.

Dave Staffen had a great year for the Dusters in 1976–1977. Performing at left wing, he scorched opponents for 87 goals and 40 assists in 74 games. Then, in the playoffs, he added six goals and five assists. Staffen was not just a scorer, either. He accumulated all those points despite spending 104 minutes in the penalty box. Playing on a line with Pierre Laganiere at right wing created a dynamic scoring duo for the Dusters. Interestingly enough, these two tied for most games played (74) and points scored (127). Many of Laganiere's 79 assists were surely responsible for setting up some of Staffen's huge total of 87 goals.

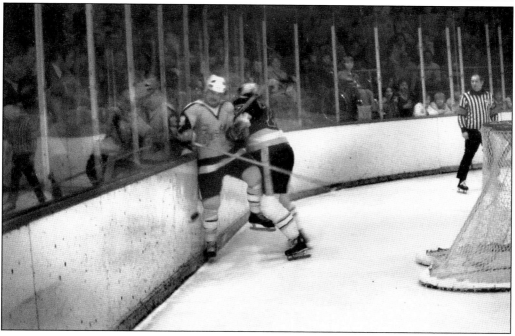

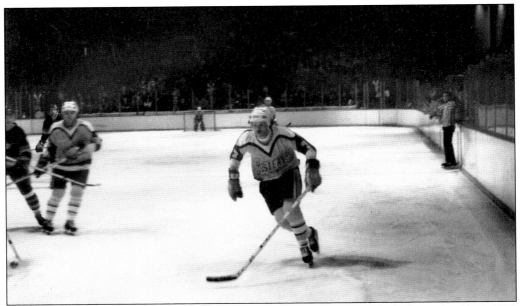

Right-winger Ken Davidson brings the puck up ice in this photograph from the 1976–1977 season. It was his third year with the Broome Dusters and his last in professional hockey. Born in Sioux Lookout, Ontario, Davidson starred at Dartmouth College, and played professionally for such franchises as the Oklahoma City Blazers, Dayton Gems, Boston Braves, and the colorfully named Albuquerque Six-Guns, before coming to Binghamton.

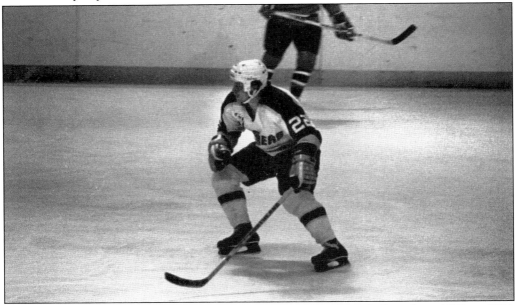

Fred Ahern grew up in Boston and was a standout at Bowdoin College from 1970 to 1974. He spent the last 30 games of that 1973–1974 season with the Salt Lake Golden Eagles. After starring in the Canadian Cup competition, Ahern spent time with the NHL's Cleveland Barons and Colorado Rockies. With the Broome Dusters in 1978–1979, his last season as a professional, Ahern played in 75 games and tallied 57 points.

Roy Carmichael had 20 assists as a defenseman for the Dusters during the 1974–1975 campaign. A native of Sardis, British Columbia, he had been purchased from the Boston Braves after only six games with that AHL club. At 5 feet 11 inches and 195 pounds, Carmichael was a physical force for the Dusters. He spent 111 minutes in the penalty box.

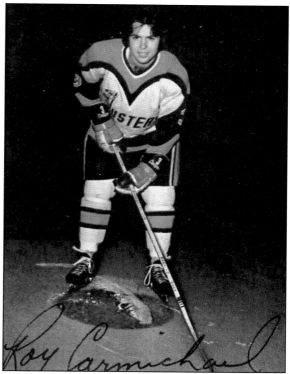

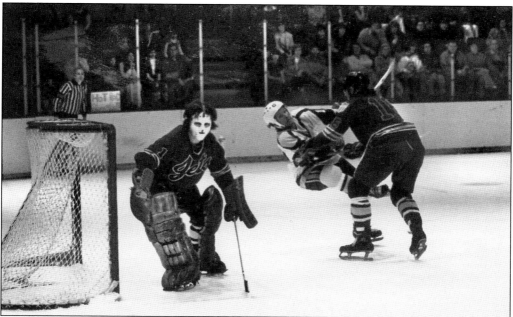

Ron Boehm was drafted by the New York Rangers in 1965. The Oakland Seals later selected him in the NHL expansion draft in June 1967. The Dusters picked him up for the 1974–1975 campaign, and Boehm proved to be a valuable addition. Playing at left wing, he appeared in 39 games, collecting 9 goals and 23 assists in his last year as a professional.

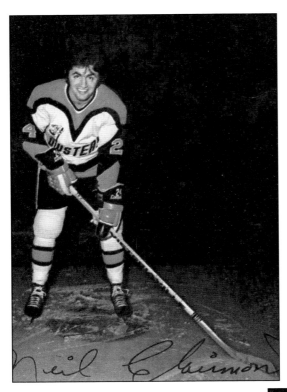

Neil Clairmont, whose brother, Wayne, coached the Dusters, was with the club from 1974 to 1976. The flashy forward contributed 35 assists in that first year, but his production diminished dramatically in the next two. Neil had 9 goals and 12 assists in 1975–1976, and a total of 26 points in 1976–1977.

It is the calm before the storm as these members of the 1976–1977 Dusters limber up before the game. Standing are Ken Davidson (No. 7) and Randy MacGregor (No. 11); crouching and clowning are Neil Clairmont (No. 24), Larry Mavety (No. 25), and Joe Hardy (No. 3).

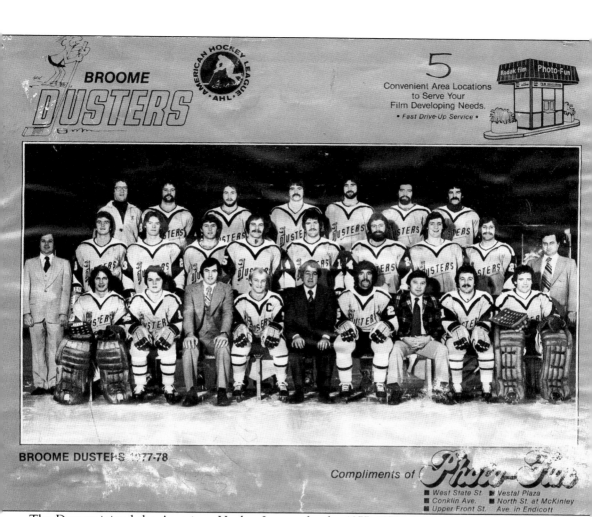

BROOME DUSTERS 1977-78

The Dusters joined the American Hockey League for the 1977–1978 season and finished dead last, winning only 27 games. However, just as they had been successful in their second year at the Arena, when they were in the NAHL, the Dusters made it to the AHL playoffs in 1978–1979. (No sophomore jinx for this franchise.)

Peter Laframboise wore No. 25 on his back, and that was the exact number of assists he had for the Dusters during the 1978–1979 campaign. He also added 8 goals, which made him the club's leader in total points for any player appearing in fewer than 50 games. He was only on the ice for 39 contests.

Rob Garner spent the entire 1978–1979 season as a Duster, and then, after a year with the Cincinnati Stingers and the Syracuse Firebirds, he returned to Binghamton—this time as a Whaler. Performing at center, Rob tallied more than 30 points in both years with Binghamton. His last year was his best in the AHL: he accounted for 53 points for the Baltimore Skipjacks in 1982–1983.

Mario Faubert was not only a tough defenseman, he was also adept at setting up goals for his teammates. He went directly from St. Louis University to the NHL's Pittsburgh Penguins for 10 games in 1974, but spent most of that season with their affiliate, the Hershey Bears. Traded to the Dusters in 1978, Faubert accounted for 40 points in 75 games.

Gary Burns, from Cambridge, Massachusetts, went from the University of New Hampshire to the Rochester Americans of the AHL in 1978. He tallied 46 points for Rochester. The Dusters acquired Burns for the 1979–1980 campaign and he did not disappoint them. The versatile 24-year-old left wing and center had 30 goals and 29 assists. The New York Rangers noticed and purchased Burns's contract for the 1980–1981 season.

Dave Forbes was a speedy left-winger who started as an 18-year-old with the Lachine Maroons of the Quebec Hockey League, and eventually, skated for the Boston Bruins from 1973 to 1977. He was with the Washington Capitals from 1977 to 1979, then came to Binghamton for his last year as a professional. In 38 games, he had 15 goals and 15 assists for the Dusters.

Lorne Molleken shared goaltending duties in 1979–1980 with Yves Belanger and Doug Keans. Molleken was in the Dusters net for 31 games, Belanger for 25, and Keans for 8. Molleken later began his coaching career as an assistant with the Moose Jaw Warriors in 1988–1989, and became head coach of the NHL's Chicago Blackhawks 10 years later.

Richard Grenier was drafted fifth overall by the New York Islanders in 1972, and spent 10 games with them. That turned out to be his only appearance in the NHL. However, Grenier was twice an All-Star in the NAHL, before coming to the Dusters in 1977. He led the AHL in goals that first year, with 46, and produced 64 points for the Dusters in 1978–1979.

The other half of the Dusters's own "goon squad," Brad Knelson appeared in 77 games in 1979–1980. His 212 minutes in the penalty box did not prevent him from assisting on 19 goals and netting 2 of his own. Teaming with fellow enforcer Rick Dorman, Knelson helped make it possible for scorers like Tom Songin and Dan Bonair to swoop in for more than 60 points each.

A native of Newfoundland, Don Howse spent half of the 1979–1980 campaign with the Dusters. It was his seventh year in the AHL, having spent the previous six with the Nova Scotia Voyageurs. In only 38 games, the strong and speedy winger tallied 30 points. The Los Angeles Kings of the NHL took notice, and Howse finished the year with them.

Born in Switzerland, Mark Hardy went to the Los Angeles Kings straight from having played four years with the Montreal Juniors. The Kings decided that Hardy needed more seasoning and so he arrived in Binghamton with the Dusters in 1979. The hard-hitting defenseman had 13 assists and 3 goals in 56 games. For the next six years, he was back in the NHL and was a fixture on defense for the Kings.

Dwight Foster was in his fifth year with the Kitchener Rangers when the Boston Bruins called up the Toronto native in 1977. Two years later, he appeared in seven games with the Dusters, then began a seven-year stretch in the NHL with the Bruins, Colorado Rockies, New Jersey Devils, and Detroit Red Wings. Maybe those seven games with the Dusters were lucky for him.

Larry Bolonchuk spent the 1978–1979 season with the Dusters. He had played in 49 games for the Washington Capitals of the NHL the previous year, then finished the season with two AHL clubs: the Hampton Gulls and the Hershey Bears. Larry played in 75 games for the Dusters and contributed 30 points to their offense while playing as a defenseman.

In 1974–1975, fresh from two years with the Junior Hockey League's Sudbury Wolves, Mike Marson, at age 19, was a regular for the Washington Capitals. After four more years of splitting time with that club and its affiliates, Marson was traded to Los Angeles and subsequently became a Broome Duster. He spent two years in Binghamton, mostly as an enforcer. He incurred 217 penalty minutes in 126 games.

No wonder Mike Meeker won the AHL's Rookie of the Year Award for the 1978–1979 season. After a brief stint with the NHL's Pittsburgh Penguins, he appeared in 75 games for the Dusters. Playing the right wing, Meeker knocked home 30 goals and had 35 assists, for a club that did not make the playoffs.

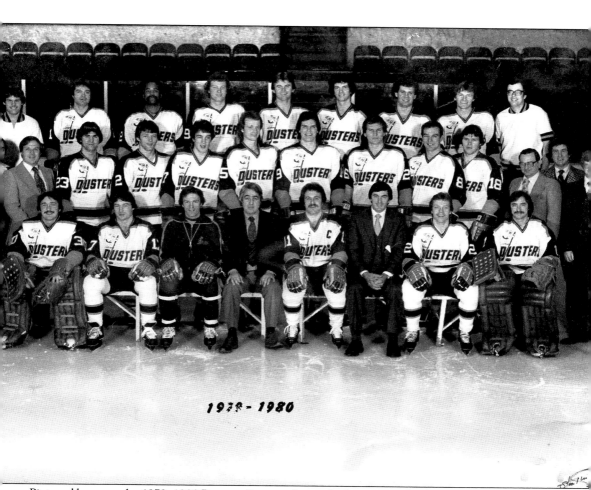

1979 - 1980

Pictured here are the 1979–1980 Broome Dusters. It was the last season for this popular franchise, which had brought so much fun and excitement to the Binghamton area. The team left behind many great memories: the four-goal game by Randy MacGregor; the very first Duster goal by Rod Bloomfield; and the club's drive to the playoffs in 1978–1979, after a last-place finish the previous year. There would be continuity for at least one Duster: Randy MacGregor joined the new guys in town, the Binghamton Whalers, and gave them three solid years of leadership and scoring as only he could.

When he was not spending some of his 151 minutes in the penalty box, defenseman Graeme Nicolson found time, in 79 games, to assist on 36 goals for the Dusters during the 1979–1980 campaign, and to add 7 goals. By 1984, he was back in Binghamton, this time as a Whaler. Nicolson had mellowed somewhat since his Duster days. In 37 appearances with the Whalers, he spent only 53 minutes in the penalty box.

Dave Gardner started his career, at age 17, in 1969, with the St. Michael's Buzzers, where he scored 96 points in just 36 games. Three years later, he was playing in the NHL with the Montreal Canadiens. Gardner's stint with the Dusters was a pit stop for him in 1979. He had already spent time with the St. Louis Blues, California Golden Seals, and Cleveland Barons of the NHL, and finished his career in Switzerland.

Rick Dorman was another key contributor for the 1979–1980 Dusters. The burly defenseman kept the other team's high scorers constantly looking over their shoulders to see if he was about to smash them into the boards—or otherwise assault them. For such crowd-pleasing antics, Dorman spent a team-leading 267 minutes in the penalty box. Only Brad Knelson, with 212 penalty minutes, came close.

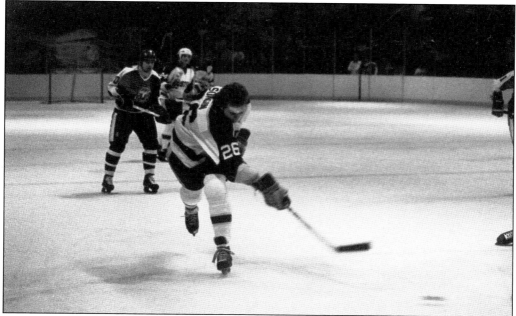

The 1979–1980 season also featured lanky winger Tom Songin. The youngster from Norwood, Massachusetts, appeared in 63 games and had a point to show for each contest. That total eventually proved to be the best of his career, although he came close with 58 the following season for the Springfield Indians.

Doug Butler was a battler for the Dusters in 1979–1980, as exemplified by his bruised lip in the photograph. He appeared in all 80 games that year, in a role that only his teammates could appreciate—protecting the club's scorers and taking on the other teams' "goons." When he was not occupied with those jobs, Butler slapped in six goals and assisted on five others. He is shown below preparing to set up one of those assists for a teammate.

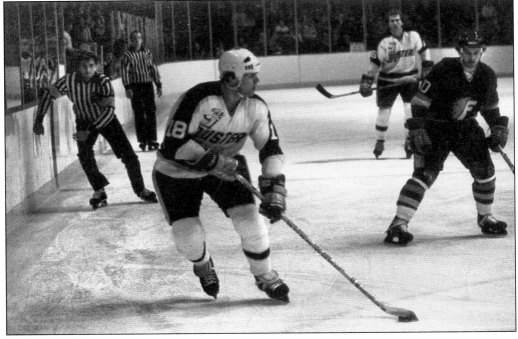

# Two

# *Binghamton Barons*
## *1976–1979*

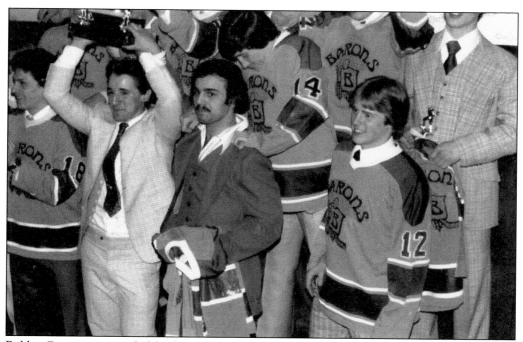

Bobby Castro, surrounded by his joyful teammates, holds the Empire Cup, awarded to the Binghamton Barons for winning the 1978–1979 championship of the New York–Penn Major Junior Hockey League. It was Awards Night for the club and owner Cliff Signor had the pleasure of handing out many individual trophies for outstanding achievement. It was the last of the Empire Cups as the league disbanded after the season.

The baby-faced goalie for the Barons, pictured here, is 18-year-old Mark Wheeler. In 1976–1977, he was the starting goalie for the club. By age 20, he was the backup goalie, which gave Wheeler time to do color commentary with Phil Jacobs, the voice of the Barons. Wheeler is still involved with the area's local players. Interestingly enough, his nephew, Eric Kelly, was the only local youngster to ever play for the B.C. Icemen.

The starting goalie for that 1978–1979 Barons championship club was Joe Shaugnessy. Not only did his team win the New York–Penn Major Junior Hockey League championship, but he also got to play that season with his brother, Pete (below). It is rare enough for brothers to play together on professional teams in any sport. How often do they get to play together on a run to the league championship?

Steve Salvucci, pictured here as a Binghamton Baron, in 1978, went to the Hampton Aces of the EHL the following year. He scored 37 goals for them in 1980–1981, and was then traded to the Saginaw Gears of the IHL. Salvucci set a personal high of 49 goals with the Gears, and won the coveted Ken McKenzie trophy for that year (1981–1982). The Hershey Bears noticed and signed Salvucci for the 1982–1983 season, but, in 73 games, the left-handed shooting winger had only 8 goals and 6 assists. His last productive years, 1983–1987, came with the Fort Wayne Komets of the IHL.

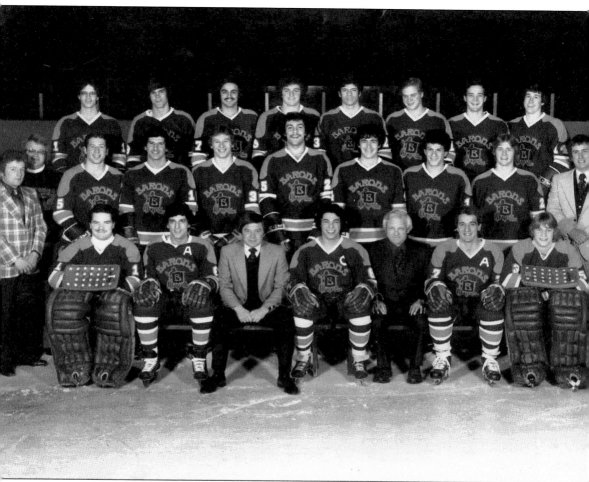

Everyone was all smiles for this Binghamton Barons team portrait, and why not? The club had pulled together and provided their fans with an exciting and successful 1977–1978 season in the New York–Penn Major Junior Hockey League. Unfortunately, the next campaign was the last for this always-entertaining club.

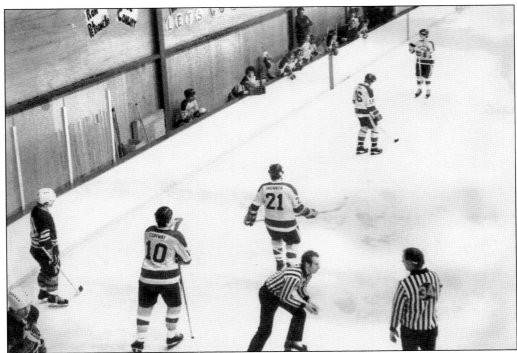

The Binghamton Barons provided a lively brand of hockey for local fans at the Chenango Ice Rink for three years, before their league went out of business. Shown above, in a game against the Buffalo Blades in 1976, are Barons skaters Mike Iadanza (No. 21), Paul Conway (No. 10), and Jay Wall (No. 16). In the action below, Barons's goalie Ron Petronella prepares himself in case the puck gets past Paul Iskyan (No. 18) and Joe Modafferi (No. 19).

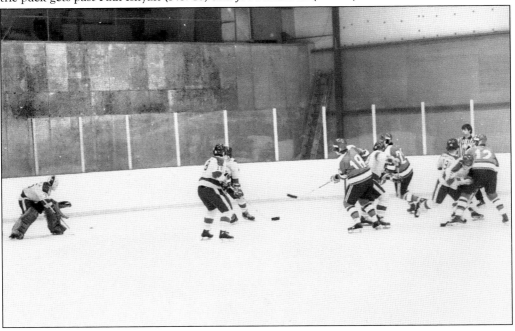

# Three

# *Binghamton Whalers*
## *1980–1990*

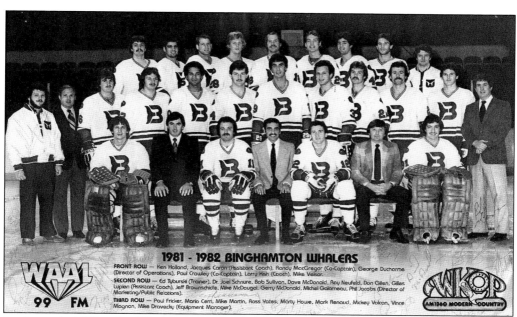

**1981 - 1982 BINGHAMTON WHALERS**

FRONT ROW — Ken Holland, Jacques Caron (Assistant Coach), Randy MacGregor (Co-Captain), George Ducharme (Director of Operations), Paul Crawley (Co-Captain), Larry Kish (Coach), Mike Veisor.

SECOND ROW — Ed Tyburski (Trainer), Dr. Joel Schnure, Bob Sullivan, Dave McDonald, Roy Neufeld, Don Gillen, Gilles Lupien (Assistant Coach), Jeff Brownschidle, Mike McDougal, Gerry McDonald, Michel Galarneau, Phil Jacobs (Director of Marketing/Public Relations).

THIRD ROW — Paul Fricker, Mario Cerri, Mike Martin, Ross Yates, Marty Howe, Mark Renaud, Mickey Volcan, Vince Magnan, Mike Dravecky (Equipment Manager).

In the early 1980s, the Whalers were the new team in Binghamton, and after losing in the first playoff round the previous year, this 1981–1982 squad finished first in the AHL's Southern Division. The Whalers then proceeded to take a tough playoff series, 3-2, from the Hershey Bears, and went on to thrash Rochester 4 games to 1. That got them to the AHL finals, where the Whalers lost to New Brunswick.

49

Official Mac Conaghy leaps to safety as winger Dan Fridgen roars down the ice. It was November 20, 1982, and Fridgen had recently arrived in Binghamton after 11 games with the Hartford Whalers. Fridgen had 22 goals and 16 assists in 48 games with the local club. Sadly, after tallying another 50 points during the 1983–1984 season at Binghamton, a severe automobile accident ended his playing career.

Mike Hoffman joined the Whalers in 1982 and stayed with the club until 1987. His best year in Binghamton was 1984–1985, when he tallied 19 goals and 26 assists. Hoffman then added four goals and an assist in the playoffs, helping the Whalers to advance to the second round. He had two productive years with the Flint Spirits of the IHL before ending his career in Germany in 1990.

Former Duster Randy MacGregor, now a Binghamton Whaler, proudly skates past his teammates on October 14, 1982, carrying the cup that signified the club's first-place finish in the Eastern Conference of the AHL for the 1981–1982 season. Besides MacGregor's leadership, Bob Sullivan's 90-point scoring, and the quality goaltending of Ken Holland and Mike Veisor were vital to the Whalers' success. Binghamton beat Hershey and Rochester in the playoffs, but lost to New Brunswick in the championship series. Below, 15 years later, Ken Holland (left) and Randy MacGregor (right) are inducted into the Binghamton Hockey Hall of Fame along with the Dusters co-founder, Jim Matthews (center).

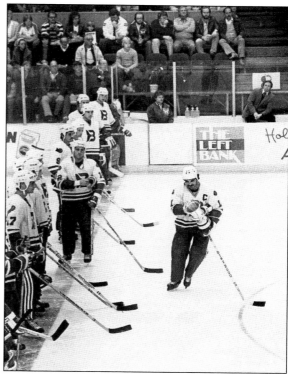

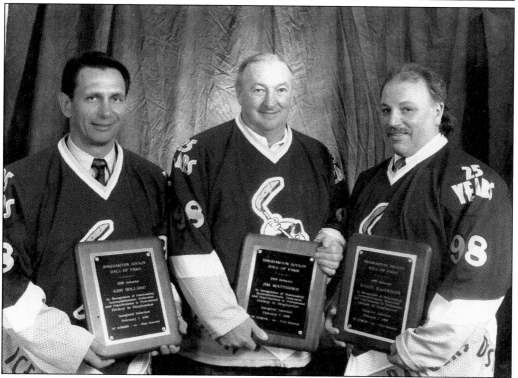

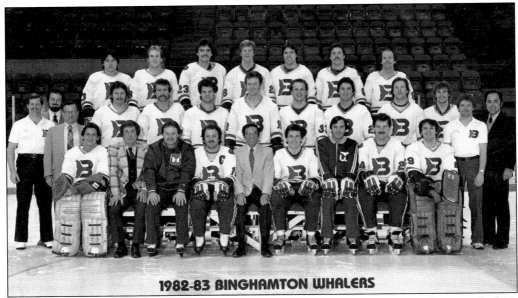

## 1982-83 BINGHAMTON WHALERS

The following year, 1982–1983, the Whalers barely squeaked into the playoffs with a record of 36-36, and were quickly eliminated. Much credit for even making the playoffs must go to goalie Paul Fricher (front row, far right). He had the league's third best goals-allowed mark, at 3.67. Ross Yates (third row, fourth from left) certainly helped the Whalers' cause, with a league-leading 125 points.

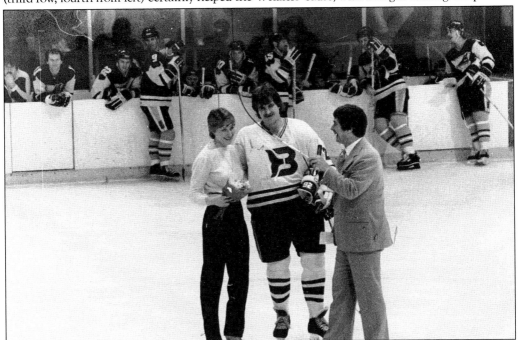

On February 26, 1982, Bob Sullivan, shown here with his wife, is congratulated by Phil Jacobs, Whalers' public relations director. Sullivan had just set an AHL record by scoring at least 1 point in 27 consecutive games. Five years later, another Whaler, Mike Richard, scored at least 1 point in 31 consecutive games to set a new AHL mark.

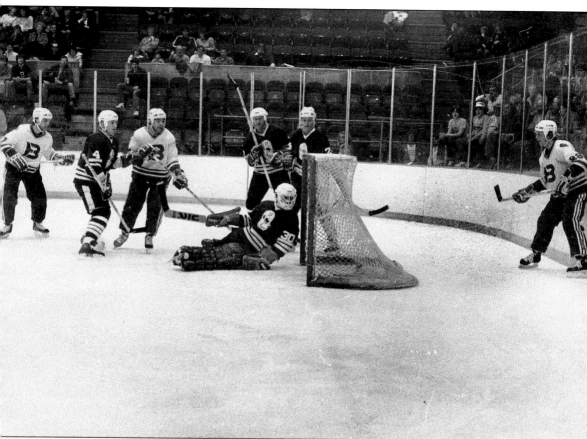

Paul Marshall scores for the Whalers in the first period of a 1982–1983 game against the Hershey Bears, as Dave Parro, the Bears goalie, dejectedly watches the puck go into the net. In 61 games during that campaign, Marshall knocked 25 shots like that into opposing nets, while assisting on 26 others. Dan Bourbonnais and Ross Yates (behind the net) got assists on this play. Bourbonnais racked up 32 other assists that year, while Yates finished with an amazing total of 84.

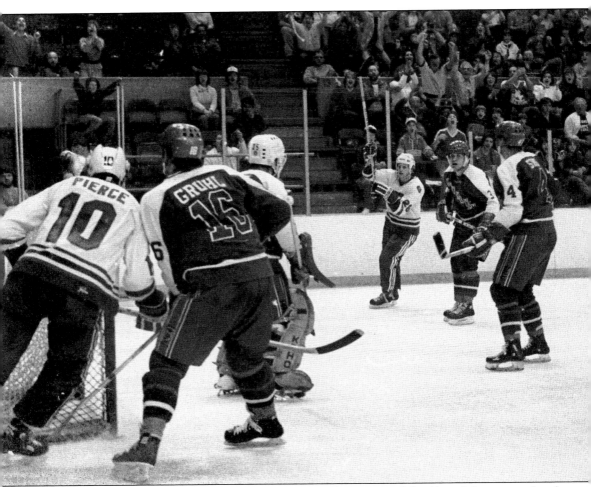

Ross Yates, with his stick in the air, has just slammed home one of the 41 goals he accumulated in the 1982–1983 season. This action took place at the Arena against New Haven in March 1983. It continued to be a great year for Yates, who finished with 125 points for the season (41 goals and 84 assists), allowing him to break the previous league record of 119 points. In addition, he had six assists in the playoffs for the Whalers, and was voted the Les Cunningham Award as the league's Most Valuable Player. Yates "fell off" the following year, when he had a mere 73 assists and 35 goals for 108 points. The rest of his career was basically spent in Europe as a player and coach.

David Jensen, shown here in 1985, was drafted by the Hartford Whalers in 1983, after his sterling play on the U.S. national team for that year. He played for the Binghamton Whalers from 1984 to 1988, while spending some time each season in the NHL: 1984–1985 with the Whalers, and the last three with the Washington Capitals. He is currently a referee in the NHL.

Mike Siltala was a high-scoring right-winger for the Whalers from 1984 to 1986. He tallied 78 points in 1984–1985 and added 10 more in that year's playoffs. Siltala came to the Whalers after scoring 114 points in 1982–1983 for the Kingston Canadiens and being a member of that league's first-team All-Stars squad. He made second-team All-Star ranking in the AHL in 1985, and was signed in 1986 by the New York Rangers.

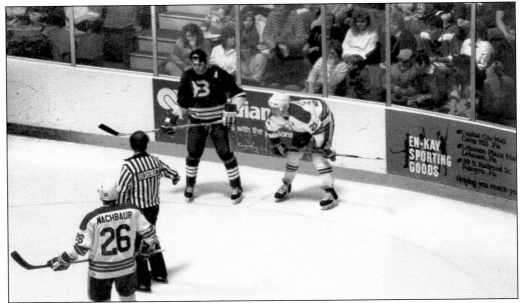

Eddie Kastelic waits to face off against the Hershey Bears in this 1986 contest. The right-winger split time between the Whalers and the Washington Capitals from 1985 to 1988, and played from 1989 to 1992 in the NHL for Hartford. Eddie returned here as a Binghamton Ranger in 1993 and appeared in 44 games. Don Nachbauer (No. 26), here with Hershey, had been a Hartford Whaler for three years.

This game, in 1985, is almost ready to begin, and both fans and Whalers mill about in anticipation. Clearly visible in front of the net are Paul Cavallini (No. 27), Bruce Shoebottom (No. 24), Yves Beaudoin (No. 7), and Shane Churla (No. 26). Active behind the net is Andre Hidi, who accumulated 104 penalty minutes that year and 13 more in the playoffs.

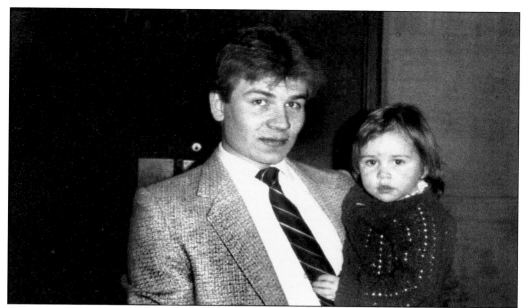

Peter Sidorkiewicz, shown here with his daughter, Ryan, was the Whalers goalie from 1984 to 1988. After being ranked second in the AHL, behind Jon Casey of Baltimore in 1984–1985, Sidorkiewicz topped all AHL goalies in 1985–1986 with a 3.19 goals against average. He was even better the following year, when his goals against average was a miniscule 2.92, although it was not enough to lead the league.

Paul Cavallini stretches during warm-ups before a 1985–1986 contest. The rugged defenseman was only with the club for 15 games that year, but in the following season he logged 188 penalty minutes in 66 games for the Whalers. Cavallini went on to spend six productive years with the St. Louis Blues and Washington Capitals in the NHL. His career ended after three years (1993–1996) with the NHL's Dallas Stars.

Yves Beaudoin was the sixth overall pick of the Washington Capitals in the annual amateur draft of 1983. After a year in the lower minors, the Caps gave the speedy defenseman a quick look in each of the next three years, but Beaudoin basically spent those seasons with the Whalers. When he accumulated 50 points during the 1987–1988 season and was still not brought back to the NHL, Beaudoin departed for Europe.

Grant Jennings was one of the "walking wounded" when this photograph was taken in 1986. The 6-foot 3-inch, 240-pound defenseman was back with the Whalers in 1987, and by the following season, was in the NHL to stay. From 1988 to 1996 he performed for the Hartford Whalers (1988–1991), the Pittsburgh Penguins (1991–1995), and briefly, with the Toronto Maple Leafs and Buffalo Sabres, until 1996.

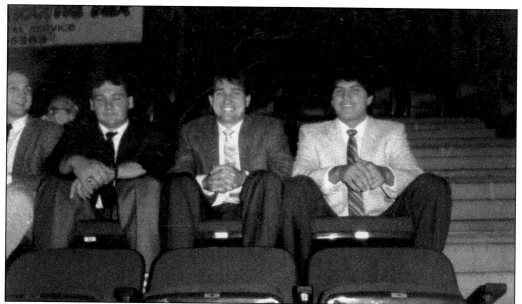

Getting a chance to watch the action, instead of being in the midst of it, these four Whalers are obviously enjoying the role of spectator in this photograph from the 1986–1987 season. From left to right are Ed Kastelic, Yves Beaudoin, Dave MacLean, and Chris Brant. The reason for their temporary status is that teams can only dress a specific number of players per game. The non-players are considered "healthy scratches."

Shown here practicing "puck balancing" is Tony Kellin. He wore No. 21 for the Whalers from 1986 to 1988. In a total of 114 games, rough-and-ready Kellin amassed 142 penalty minutes. While on the ice, he had 14 goals and 39 assists for the club. In 1987, he even notched a goal in that year's playoffs.

Yvon Corriveau, shown here providing an autograph for a young admirer during the 1987–1988 season, played in 35 games for the Whalers that year. He had come up briefly for seven games with Binghamton in 1986–1987. His 15 goals and 14 assists in those 35 games attracted attention, and he finished the season in the NHL with the Washington Capitals.

When he arrived in Binghamton, Tommy Martin had already played briefly in the NHL with the Winnipeg Jets from 1984 to 1987, and for five games with the Hartford Whalers in the fall of 1987. The flashy left-winger quickly became a fan favorite, with 28 goals and 61 assists to his credit. He was only five points behind Mike Richard for club leadership when he was recalled to the NHL in 1988.

60

Two years after a sensational season (161 points) as a 19-year-old with the Saskatoon Blades of the WHL, Roger Kortko was splitting time between the New York Islanders and the Springfield Indians of the AHL. In 1985–1986, Kortko got a 52-game opportunity with the Islanders, but could produce only 5 goals and 8 assists. That led to his spending 1987–1989 with the Binghamton Whalers, where he contributed 129 points.

Jim Culhane played for Western Michigan University from 1983 to 1987. For the following three years, he was on the ice for the Binghamton Whalers and appeared in more than 70 games in each of those campaigns. His best season was 1987–1988, when he tallied 22 points. Culhane returned to Western Michigan University and was an assistant coach there for eight years.

Fans are always catered to by management with prizes, contests, giveaways, and such, but one "extra" for the fans stands out at the Arena, and that is the monthly skate-around. On those occasions, fans who have brought their skates are invited to come out on the ice after the game. Their antics are always amusing to watch. In the photograph above, Binghamton Whaler goalie Kay Whitmore enjoys the show after a 1987 game. Whitmore had a serious side, too (left). He worked hard at his trade, and it paid off four years later when he became the regular goaltender for the Hartford Whalers.

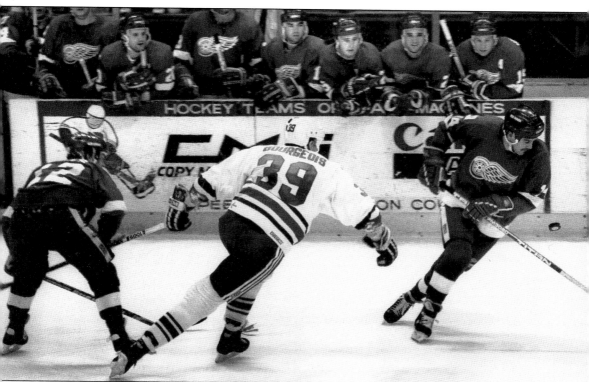

Charlie Bourgeois, nicknamed Boo-Boo, was signed out of the University of Moncton in 1981 by Calgary. The Flames were so impressed with the 6-foot 4-inch, 220-pound defenseman that they brought him up for 54 games during that year's campaign. However, seven years later, despite a fine season with the Binghamton Whalers, Bourgeois saw that his future lay elsewhere. Where would a Bourgeois go to play? Why, Paris, of course (in 1989).

Flashy center Mike Richard was a Whaler in 1987–1988, and had a sensational year for them. In 72 games, he had 46 goals and 48 assists, and was awarded the Dudley "Red" Garrett Memorial Award as the league's top rookie. The following year, Richard was scoring even more points (107), but not for the Whalers. He was now playing for the Baltimore Skipjacks.

Bob Bodak is shown here during a free skate, when he was still with the Binghamton Whalers. The grinning fan is Andy Ryder. Bodak and Chris Cichocki were both free agents after the 1989–1990 campaign, the Binghamton Whalers' last. That status enabled them to sign with the Binghamton Rangers. They were the only Whalers to do so.

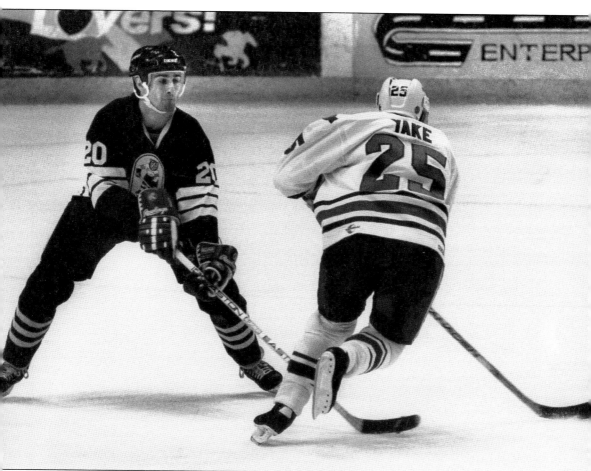

The Whalers center from 1988 to 1990, Terry Yake, makes his move here against a Hershey Bears defender. Those moves brought results for Yake, especially in his first year with the Binghamton club. In 75 games, he had 39 goals and 56 assists. Yake had 13 goals and 42 assists the following year, and in both seasons had brief stays with the parent club, the Hartford Whalers.

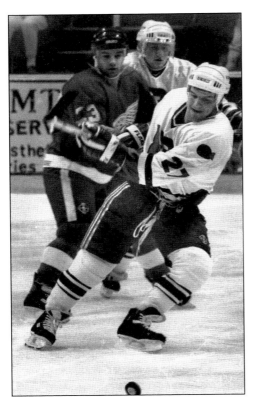

Shown here fighting for the puck in 1989 is Binghamton Whaler Michel Picard. At age 20, the youngster at left wing showed great promise. He finished that season with 16 goals and 24 assists. The following year, Picard proved that his potential was not being overestimated, as he knocked home 96 points—but for the Springfield Indians.

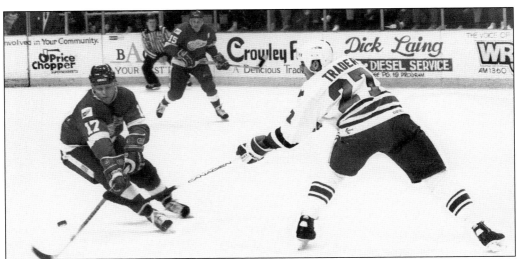

Larry Trader had played for the NHL's Detroit Red Wings, St. Louis Blues, and Montreal Canadiens before being picked up by Hartford as a free agent in 1988. Trader felt comfortable in the AHL. He had scored 56 points in 1985–1986 for the Adirondack Red Wings, and is pictured here skating against his former team. Trader had 51 points for the Binghamton Whalers in 1988–1989.

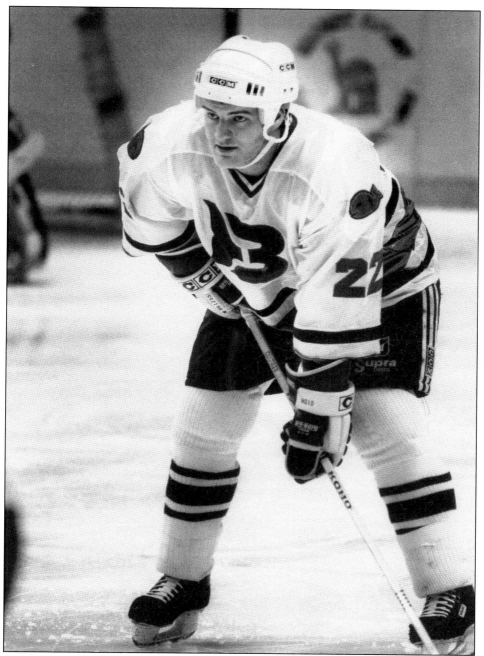

At the age of 17, Brian Chapman played amateur hockey in 1985 with the Belleville Bulls of the OHL. Just one year later, the sturdy defenseman was on the ice for the Binghamton Whalers, although only for one game. In the 1989–1990 campaign, Chapman contributed 5 goals and 25 assists, while accumulating 216 minutes in penalties. He slumped to 17 points in 68 games in 1989–1990, although he knocked down enough opponents to earn 180 minutes in the penalty box. Fifteen years later, "Chappy" was still skating professionally with the Springfield Falcons.

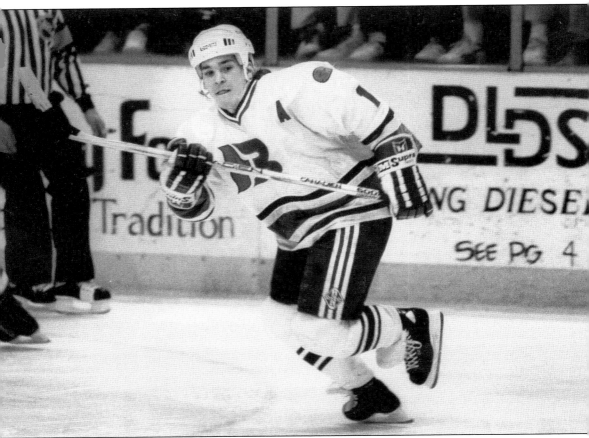

Chris Cichocki grew up in Detroit, Michigan, dreaming about playing for the NHL's Detroit Red Wings. Remarkably, after three years of collegiate hockey with the Michigan Tech Huskies, he was actually signed by the Red Wings in June 1985. However, Cichocki's dream was short-lived. Despite a solid year with Detroit in 1985–1986 (21 points in 59 games), he was sent to the Adirondack club of the AHL, and subsequently was traded to the New Jersey Devils. By 1989, Cichocki was a Binghamton Whaler, and when that team was replaced at the Arena by the Binghamton Rangers, he played for them from 1990 to 1993. Despite 65 points scored in 1990–1991, and more than 50 in each of the next two years, Cichocki was never again invited to rejoin the NHL.

# FOUR

# *Binghamton Rangers*
## *1990–1997*

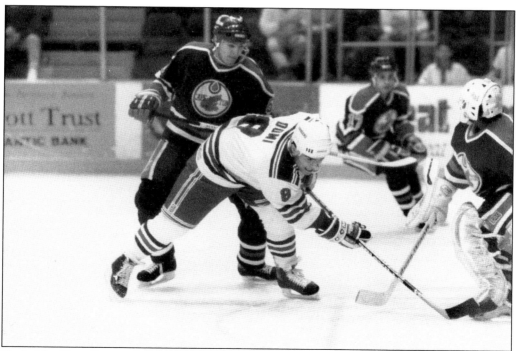

Trailed by Cape Breton Oilers, Tie Domi—better known as "The Albanian Assassin"—takes a shot at goal. Actually born in Windsor, Ontario, as Tie Tahir, the tough little right-winger was Toronto's second pick in the 1988 draft. In 1990, he was traded to the New York Rangers, who sent Domi to the Binghamton club. Twenty-five games later, he was in the NHL to stay.

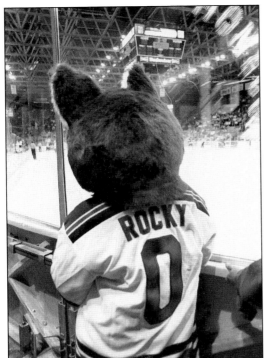

The Binghamton Rangers' mascot, Rocky Raccoon, shown here gazing at the rink, is that club's contribution to local folklore. Mascots must be able to interact with the crowd, encourage them in cheering on the home team, and make kids feel special. Rocky Raccoon could be counted upon to do all of the above and more at every home game.

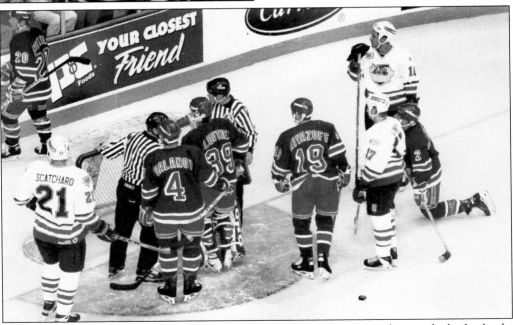

Think that hockey is not that tough a game? Besides the players getting beat up by body checks and punches during games (and sometimes afterwards), even the nets are not safe. Here, after a Syracuse Crunch player had slammed into the post and separated the goal from its pegs, the linesmen attempt to repair it. Players from both Syracuse and the Binghamton Rangers offer their, probably, unsolicited advice.

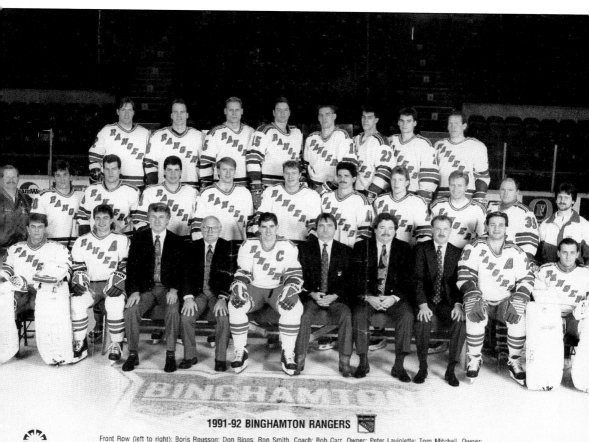

**1991-92 BINGHAMTON RANGERS**

Front Row (left to right): Boris Rousson; Don Biggs; Ron Smith, Coach; Bob Carr, Owner; Peter Laviolette; Tom Mitchell, Owner; Jim McCoy, Owner; Al Hill, Assistant Coach; Peter Fiorentino; Mark Laforest.
Middle Row (left to right): Jon Smith, Trainer; Chris Cichocki; Mike Stevens; Jody Hull; Jeff Bloemberg; Brian McReynolds; Ross Fitzpatrick; Steven King; John Mokosak; Sam St. Laurent; Mark Dumas, Equipment Manager.
Back Row (left to right): Daniel Lacroix; Joe Paterson; Shaun Sabol; Mark Janssens; Ric Bennett; Rob Zamuner; Mike Hurlbut; Eric Germain.

**1991-92 SOUTHERN DIVISION CHAMPIONS**

OAKDALE MALL

PERHACH PHARMACY

The new guys in town, the Binghamton Rangers, finished second to Rochester in the Southern Division in 1990–1991. The Rangers defeated Baltimore in the playoffs that year, then lost to Rochester in the second round. The 1991–1992 Rangers, pictured here, finished first in the Southern Division, five points ahead of Rochester, but their revenge was short-lived. Rochester knocked them out of the playoffs again at season's end.

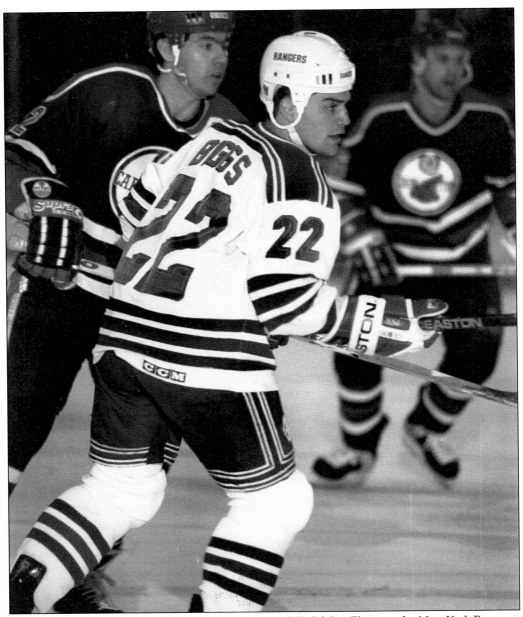

On August 8, 1991, Don Biggs was traded from the Philadelphia Flyers to the New York Rangers, who subsequently sent him to Binghamton. The AHL was definitely not a new setting for Biggs. He had already spent seven years with the AHL's Springfield Indians, Nova Scotia Oilers, Hershey Bears, and Rochester Americans. Always a prolific scorer, Biggs had notched 103 points for Hershey in 1988–1989, 90 in 1989–1990 for the Bears, and 88 for Rochester before arriving in Binghamton. It was, therefore, no great surprise when Biggs racked up 82 points in his first year at the Arena. It must have raised some eyebrows, however, when Biggs, now a captain for the club, set records for the Binghamton Rangers in 1992–1993 for assists in one season (84) and points (138). The biggest surprise was yet to come. He was released at the end of that season and spent the rest of his career in the IHL.

Nothing brings the fans to their feet like a goal for the home club. The recipient of the crowd's appreciation in this 1991–1992 photograph, Binghamton Ranger Steven King (right), was pretty excited, too, as his raised stick shows. Clearly visible is the puck in the corner of the net. No doubt about that one being a goal. King is shown below about to be clobbered by an eager Rochester American's stick as Olaf "Olie the Goalie" Kolzig makes sure that the shot is wide. Years later, Kolzig was awarded the Vezina Trophy as the NHL's best goalie while playing for the Washington Capitals in 2000.

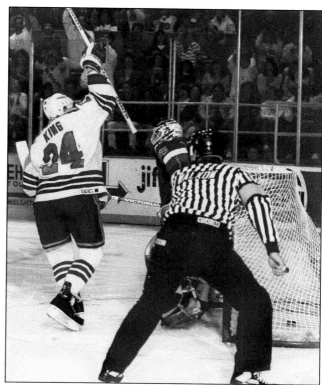

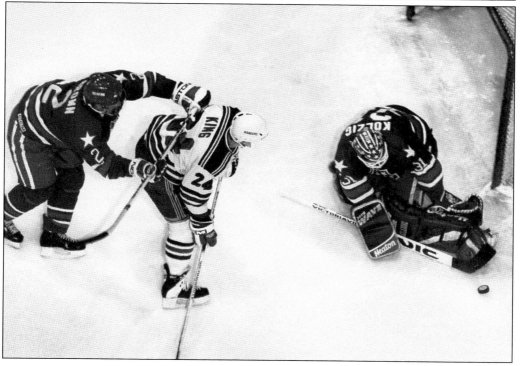

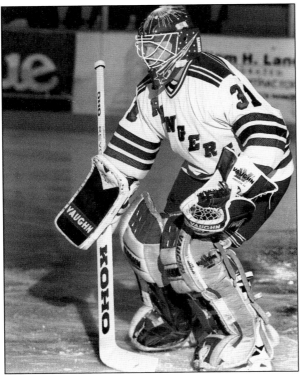

Corey Hirsch was in goal for the Binghamton Rangers in 1992–1993. In 46 games, he had a fine 2.79 goals against average. He won the Hap Emms Memorial trophy and was the starting goalie in the AHL All-Star Game that season. Just one year earlier, Hirsch had been named the Canadian Major Junior Goaltender of the Year. He was the New York Rangers No. 1 goalie when the NHL lockout was imposed in 1994.

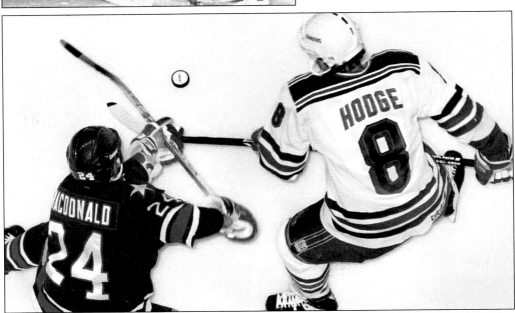

Ken Hodge Jr., of the Binghamton Rangers, battles for the puck with Doug MacDonald in this 1993 action. Hodge is the son of NHL veteran Ken Hodge, who, after a fabulous career with the Boston Bruins, played for the Dusters in his last year and theirs. Ken Hodge Jr. had some looks from NHL clubs, including the Bruins, then ended his career with the Cardiff Devils of Great Britain in 1998.

Every team needs an enforcer to protect its vulnerable scorers and set the tone on the ice. One of the toughest was Darren Langdon—shown here doing his thing against the Cornwall Aces. Langdon played in the AHL with the Binghamton Rangers from 1992 to 1994, got to the parent club late in 1993–1994 for 18 games, and did so well that he was still with them, "keeping the peace," in 2000.

Craig Duncanson, shown here battling for the puck against Rochester, had already played for the Los Angeles Kings and Winnipeg Jets of the NHL when he was signed as a free agent by the New York Rangers in September 1992. For the next three years, he excelled for the Binghamton Rangers with scoring totals of 94, 69, and 64 points. Duncanson later became a college coach.

After a brief respite due to a minor injury, Mike Richter dons his gear prior to getting back into action in goal for the Binghamton Rangers during the 1992–1993 season. He was only in six games with Binghamton, having spent 38 with the parent club, but the talented goaltender opened some eyes when he turned in a miniscule goals against average of 1.18. That performance convinced the New York Rangers that Richter belonged in the NHL, and he went on to spend the rest of his career in the net for them.

Mike Dunham is the only native of Broome County to have made it to the NHL. Born in Johnson City in 1972, he was named to the National Collegiate Athletic Association All-America East first team in 1992–1993, while he was a student at the University of Maine. In addition, Dunham was twice a member of both the U.S. national and Olympic teams. From 1993 to 1996, he skated against the Binghamton Rangers as a member of the AHL's Albany River Rats, before joining the New Jersey Devils for 1996–1997. He has been in the NHL since then, with the Devils, the Nashville Predators, and now, the New York Rangers. Prior to the NHL lockout of 2004–2005, Dunham was the New York Rangers' No. 1 goaltender.

After three seasons as a star for the University of Maine (he was on the Hockey East All-Star first team in 1991 and 1992), and two tours with the Canadian national team, Jean-Yves Roy arrived in Binghamton. He had been signed as a free agent by the New York Rangers on July 20, 1992. During the 1992–1993 campaign, Roy had 13 goals and 15 assists in 49 games. "J-Y" improved to 65 points the next year and blossomed into stardom during the 1993–1994 campaign with 77 points. After helping Canada to win a silver medal in the 1994 Olympics, Roy was traded to the Ottawa Senators in 1995.

Jon Hillebrandt spent three years (1993–1996) in goal for the Binghamton Rangers. His best year for them was 1995–1996, when he appeared in 36 regular-season and 2 playoff games. For the next two years, he was still in Binghamton, but as a member of the B.C. Icemen. In 1997–1998, Hillebrandt had a fine 3.24 goals against average, having made 1,033 saves in 36 games.

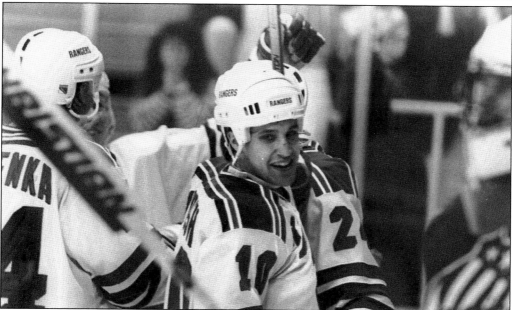

The Arena erupts as Binghamton Rangers' center, Shawn McCosh (No. 10) and defenseman Darcy Werenka celebrate this goal during the 1993–1994 campaign. McCosh had 31 goals that season to go with 44 assists. He was even better the following year, tallying 83 total points. Neither McCosh nor Werenka ever made it to the NHL, but memories of moments like this can last a lifetime.

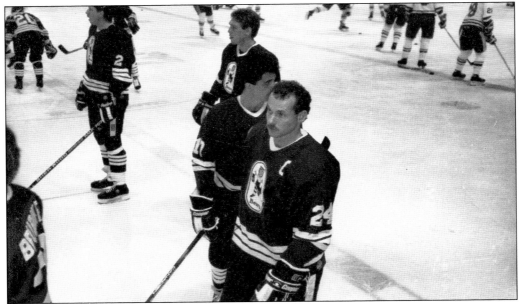

The center for the Hershey Bears team that won the Calder Cup in 1987–1988 was none other than Al Hill, pictured in uniform here. Binghamton knew him best as coach of the Rangers from 1993 to 1995. In his first year, the club finished last in the Southern Division, although they missed earning a playoff spot by only two points. Hill proved himself in 1994–1995, when his Rangers rose to first place in their division.

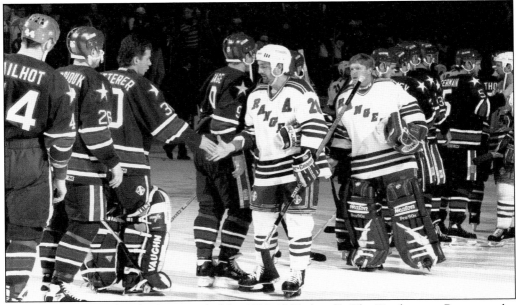

This was the scene after the first round of the 1994–1995 playoffs. The Binghamton Rangers, who had finished first in the league's Southern Division, won that series 4-1. Previously, Rochester had made a habit of knocking Binghamton out of the AHL playoffs, so it had to be gratifying for the Rangers to find themselves on the winning side of the traditional handshakes. Unfortunately, Cornwall knocked Binghamton out in the next round, four games to two.

From 1994 to 1996, identical twin brothers Chris (above left) and Peter Ferraro were fan favorites at the Arena. Chris came to the Binghamton Rangers in the spring of 1995 from the Atlanta Knights of the IHL. Arriving in time to play in only 12 regular-season games, he showed so much promise that the Binghamton Rangers had him on the ice for all 10 playoff games, where he scored 5 points. In 1995–1996, Chris tallied 48 goals and 53 points. Peter Ferraro (below left) had a brilliant year in 1995–1996. He was third in the league with 102 points on 34 goals and 68 assists. Port Jefferson, New York, can certainly take pride in these two native sons.

Shawn Reid was a defenseman for the Binghamton Rangers from 1994 to 1996. He sparkled in the 1994–1995 playoffs, where he had three assists in nine games and played tough defense. Encouraged by his performance in the Calder Cup competition, the Binghamton Rangers played him in 45 games the following year. When he produced only five assists and no goals, Shawn was not re-signed.

Barry Richter (left) and Jamie Ram were both with the Binghamton Rangers from 1994 to 1996. Ram was a rarely used goalie, who did record a shutout in each of those two years. He then spent two seasons with the Kentucky Thoroughblades (1996–1998), followed by a year with the Cincinnati Mighty Ducks—both clubs in the AHL. His last year of play was with the Canadian national team in 1999–2000.

Andy Silverman arrived as a Binghamton Ranger defenseman in 1994. He got his big chance in 1995–1996, when management put him on the ice for 75 games, plus 4 playoff appearances. Sadly, he accumulated only 5 goals and 15 assists in those contests. Silverman was only on the ice for 20 games the following year, and with but 1 assist to show for his efforts, his AHL career came to an end.

At 6 feet 6 inches and 230 pounds, Eric Cairns was built to be a defenseman, and he learned to use his size to good advantage. At age 17, Cairns was already racking up 237 minutes in the penalty box for the Detroit Ambassadors of the OHL. After two seasons with the Detroit Junior Red Wings, Cairns split the 1994–1996 seasons between the Binghamton Rangers and the parent club.

Scott Malone wore No. 3 for the Binghamton Rangers from 1994 to 1997. His first year with the club was eventful for the rookie defenseman. Not only was he on the ice for 48 contests, but Malone also participated in 11 playoff games and had 2 assists in the postseason. The following year, he played in 58 regular-season contests and in all 4 games of a losing playoff series with Syracuse.

Sylvain Blouin came to the Binghamton Rangers in the spring of 1995. In his first full season with them, Blouin was on the ice for 71 games, with only 5 goals and 8 assists to show for his efforts. After a 6-day trial with the New York Rangers, he improved to 30 points in 62 games with the Binghamton Rangers in 1996–1997.

Noted primarily for its football teams, Wisconsin University can also take pride in hockey's Barry Richter. After graduating from the university, Richter played for both the U.S. national team and the 1994 Winter Olympics squad. After 21 games with the Binghamton Rangers in the spring of 1994, he tallied 56 points in 73 games in 1994–1995. In 1995–1996, Richter collected 81 points and was selected to the AHL's All-Star team. The following year he was in the NHL, but not with the New York Rangers; he had been traded to the Boston Bruins.

Brad Jones, shown here in his Rangers uniform, tallied 52 points for the Binghamton squad in 1995–1996. After a year in Germany, he returned with the B.C. Icemen and scored 65 points for them in 1997–1998. He was made their coach the following year. Shown below, nattily attired in jacket and tie, Jones watches the action intently. Also fully focused on the game are members of his B.C. Icemen. The players are, from left to right, Derek Knorr, Chris Grenville, Justin Plamondon, Jarno Mensonen, Dmitri Deryabin, and Chris Kavanagh. Jones guided the Icemen to a record of 156-111-29 over a 4-year period, including 3 playoff appearances. On March 19, 2005, he was inducted into the Binghamton Hockey Hall of Fame. A well-deserved honor for this fine coach.

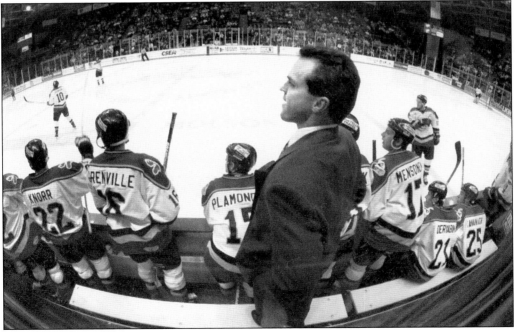

Andrei Kudinov is shown here skating in a March 1, 1996 contest. The speedy center arrived late in 1993 and played in only 25 games that season. For the next two years, he appeared in 123 games and contributed more than 30 points in each of those seasons.

Right-winger Ryan Vandenbussche was signed as a free agent by the New York Rangers in August 1995, and played the entire 1995–1996 season with the Binghamton Rangers. In 68 games, he had 3 goals and 17 assists. Vandenbussche got a look with the parent club for 11 games in the fall of 1996, then was sent back to Binghamton. He was eventually traded to the NHL's Chicago Blackhawks.

Rick Willis was with the Binghamton Rangers from 1995 to 1997. In 1996–1997, playing at left wing, he appeared in 73 games. Binghamton had finished last in the Empire State Division that year, barely making the playoffs. That set up the Rangers to play the Canadian Division winner, St. John's, who proceeded to easily dispose of Binghamton in four games. Willis recorded a goal and an assist in that series.

Binghamton Rangers captain Ken Gernander was not often caught just watching the action. He spent 10 years in the AHL, during which time he was called up for only 10 games by the New York Rangers of the NHL. His best year as a Binghamton Ranger was 1995–1996, when he scored 73 points and won the Fred Hunt Memorial Trophy for Sportsmanship.

Left-handed defenseman Lee Sorochan played two full seasons with the Binghamton Rangers (1995–1997). He scored only 10 points in his first year, then improved to 31 in the following season. Sorochan had a busy season in 1998–1999, when he spent time with the Fort Wayne Komets, the Hartford Wolf Pack, the St. John Flames, and even squeezed in two games with the NHL's Calgary Flames.

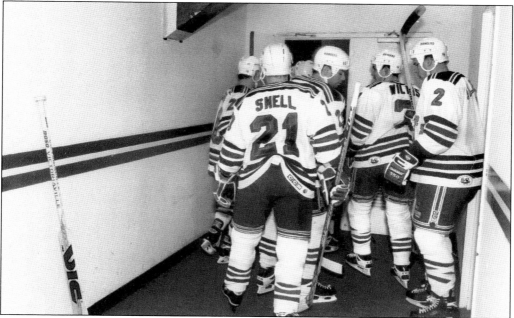

With Chris Snell (No. 21) and Andy Silverman (No. 2), both defensemen, bringing up the rear, the Binghamton Rangers head toward the ice for an April 1996 playoff game against the Syracuse Crunch. The Rangers were eventually eliminated from Calder Cup action, when they lost that series, three games to one. Snell had six points in the four games, while Silverman was scoreless.

Russian-born Maxim Galanov arrived in Binghamton in 1995 and spent two years with the Binghamton Rangers. The burly defenseman was also a scoring threat. In his first season at the Arena, Galanov had 17 goals and 36 assists. He was invited to join the New York Rangers for the 1997–1998 season. His time in the Big Apple lasted for only six games, and after a few unproductive looks from other NHL clubs, Galanov returned to Russia.

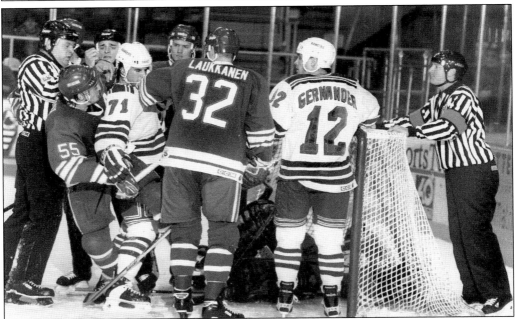

Ken Gernander (No. 12) watches as Peter Ferraro (No. 71) is mauled in front of the Portland Pirates' net in this March 1, 1996 contest. As previously mentioned, Ferraro had a great season in 1995–1996, with 101 points scored in 68 games. He was no slouch the following year either, when he added 38 goals and 39 assists to his resume.

Dan Cloutier was the Binghamton Rangers goalie for the 1996–1997 season. After splitting time between the NHL Rangers and the Hartford Wolf Pack of the AHL in 1997–1998, Cloutier joined the New York Rangers full-time in 1998–1999 and produced a nifty 2.68 goals against average. He was Vancouver's No. 1 goalie when the NHL declared a lockout in 2004.

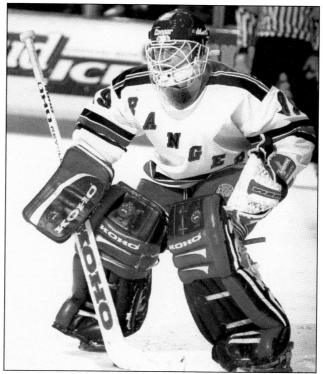

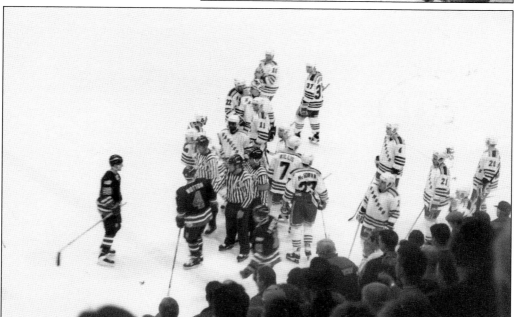

Someone once waggishly commented that he was watching the fights when a hockey game broke out. Hockey fans would probably agree that players do occasionally lose their tempers, take off the gloves, and go at it. In this case, the Binghamton Rangers and the Springfield Indians could not wait, as they started to go at it during the pregame warm-up!

The Celebrity Classic game is always a special occasion at the Arena. While it may not count in the standings, pride is at stake for the participants. Pictured above is the current general manager and part-owner of the Binghamton Senators, Tom Mitchell. The goalie (below) is Bob Carr, who was a part-owner of both the Binghamton Whalers and the Binghamton Rangers, and now has that role with the Binghamton Senators. Mitchell and Carr are two dynamic and knowledgeable hockey executives who know their way around both on and off the ice.

# FIVE

# *B.C. Icemen*
## *1997–2002*

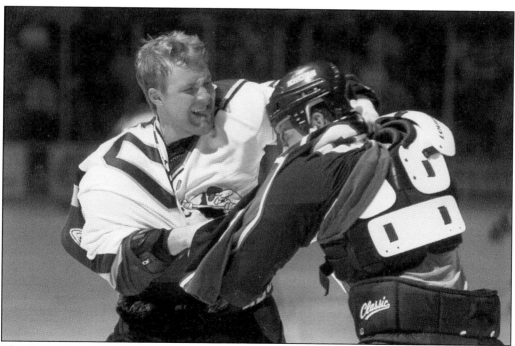

The Icemen's most volatile player during the 1998–1999 season was, clearly, left-winger Pete Vandermeer. He garnered only 36 points, but his propensity for the type of activity pictured here led to a whopping 390 minutes in the penalty box. Vandermeer controlled himself during that season's playoffs—he had two goals, two assists and, remarkably, no penalty minutes in five games.

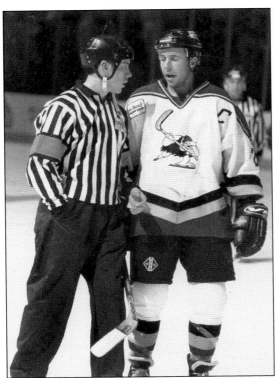

Shown here having a "friendly" discussion with one of the linesmen, the B.C. Icemen's Greg Pajor was with the club for three seasons (1997–2000). His best year was 1998–1999 when, after being moved to the center position from his usual right-wing spot, he knocked home 40 goals and had 42 assists.

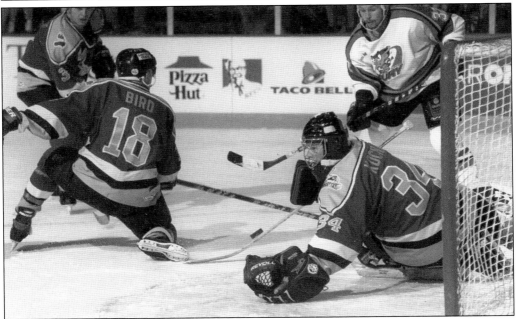

Jamie Bird slides to the defense of his goalie, Dieter Kochan, who is caught off balance by a charging Muskegon Fury player. In his role as a defenseman for the Icemen, from 1997 to 2000, Bird always seemed to be in the right place at the right time. He could score, too. Bird had 115 assists in those three years, plus 8 in the playoffs.

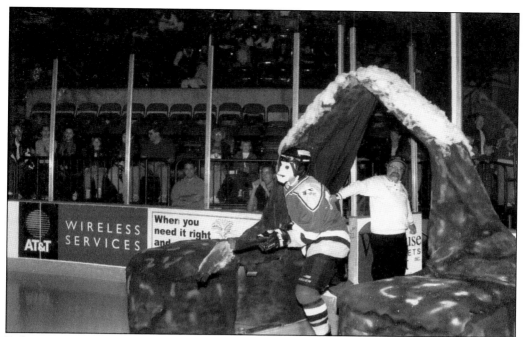

Before every game played by the B.C. Icemen, their mascot, Bamboni, made a fiery entrance onto the ice. The specially constructed archway produced a crowd-pleasing visual effect, and hopefully, got the Icemen's adrenalin going before the game. It certainly always worked for the fans.

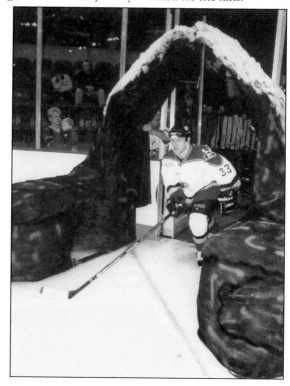

Following Bamboni is Derek Wood. Always a dependable and spirited performer, Wood spent four seasons with the Icemen (1998–2002). He accumulated 84 goals and 144 assists during those 4 seasons, and rarely avoided a fight. That is evidenced by the 233 minutes that he spent in the penalty box.

Ales Dvorak stuck around for only two campaigns with the Icemen (1998–2000). A defenseman, he played in a total of 127 regular-season games, plus 7 playoff contests. Unfortunately, that amount of playing time resulted in Dvorak's scoring only 14 points.

For the 1998–1999 and 1999–2000 campaigns, Patrice Robitaille was at right wing for a B.C. Icemen line, for 71 and 72 games respectively. He also appeared in 11 playoff games, where he collected 5 points on 4 goals and an assist. Robitaille had 75 points in his first year, and improved to 89 in his second. That total included 59 assists.

Mark Dutiaume played for the B.C. Icemen from 1998 to 2001. Always a prolific scorer, Mark accumulated 62 and 66 points in his first two years with the club. During the 2000–2001 season, Dutiaume was given some time at center, instead of on the wing, which caused his production to fall to 47 points. Whether that move affected his decision to leave the Icemen is unknown, but Dutiaume chose to play in England the following year.

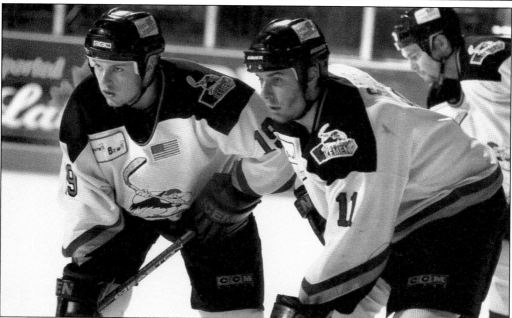

It is playoff time for the B.C. Icemen at the tail end of the 2001–2002 season, and No. 19 Mike Nelson (left) and Trevor Shoaf are clearly ready. Both of them appeared in six playoff games, where they racked up some penalty minutes but no points. Nelson was not with the club during the regular season, while Shoaf contributed 16 points.

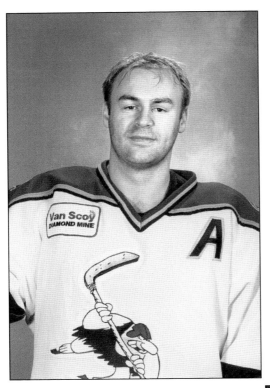

Derek Knorr spent the 1998–2001 seasons with the B.C. Icemen. He started out with a fine 64-point campaign, and added 4 points in the playoffs of 1998–1999. He then contributed 58 points the following season, plus 3 playoff points. The club missed the playoffs in 2000–2001, and Knorr's production had declined, as well, to 37 points for the year.

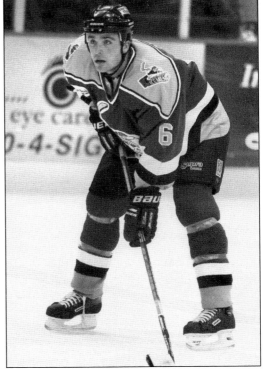

Scott Ricci skated with the B.C. Icemen for 57 games in each of the 1998–1999 and 1999–2000 seasons. He also appeared as a valuable defenseman in 11 playoff games during those years. Ricci scored a total of 10 goals and had 37 assists for the Icemen during regular-season action and tallied 2 goals in the playoffs.

The aforementioned Derek Wood made a brilliant debut in 1998–1999 as a rookie for the Icemen, when the speedy center garnered 12 goals and 10 assists in just 18 games. He added three more assists in the playoffs. That led to Wood being on the ice for 72 regular-season games the following year, during which he tallied 75 points.

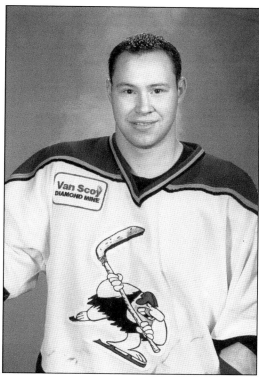

Rob Voltera skated for the B.C. Icemen for the last three years of that organization's existence (1999–2002). The 2000–2001 campaign was his best—in 69 contests, he collected 25 goals and 23 assists. Voltera might have scored even more were it not for the 277 minutes he spent in the "sin bin" that season because of penalties.

Dieter Kochan had quite a year in 1999–2000. After serving as the Icemen's starting goalie the previous season, he was enjoying a record of 29 wins against only 11 losses when the NHL's Tampa Bay Lightning noticed. The Lightning signed Kochan as a free agent in March 2000, and brought him right up to the parent club. Kochan thus became the first United Hockey League (UHL) player to ever jump directly to the NHL. He spent 238 minutes in goal for Tampa Bay that season and established himself as an NHL-caliber goalie. Not bad for a young man from Saskatoon, Canada, who had been picked at No. 98 in the 1993 Draft by Vancouver.

Jamie Bird was a consistent performer as a defenseman for the B.C. Icemen from 1997 to 2000. He was on the ice for more than 70 games in each of those seasons, including playoffs, and yet managed to incur only 45 minutes (or fewer) in penalties in any of those years. His best season was his first (1997–1998), when he had 54 assists and another 4 in the postseason.

After playing in 48 games for the Icemen in 1999–2000, and accumulating 77 penalty minutes, Martin Cote was not with the club the following year. A look at his record reveals that he produced only two assists and no goals that season, while skating both at the wing and as a defenseman.

Matt Ruchty was at left wing for the B.C. Icemen when he joined them for the 1999–2000 campaign. However, Ruchty's 321 penalty minutes during the regular season, plus 12 in the playoffs, logically led to his move to defense for the following year. The switch made little difference to Ruchty, who accumulated 322 penalty minutes at his new position. He could score, too. In 1999–2000, Ruchty accumulated 43 points, including 3 in that year's playoffs. After being switched to defenseman, he still swooped in on opposing goalies for 15 goals and added 20 assists in 2000–2001.

Justin Plamondon played in just 12 regular-season games for the B.C. Icemen in 1997–1998, but was so impressive that he saw action in 5 playoff games and notched 2 assists. Plamondon had proven himself and he appeared in more than 70 games for the Icemen in each of the next 4 seasons, never scoring fewer than 40 points per campaign. He was consistent in his scoring, as well, with 48 points in 1998–1999, 49 in 1999–2000, 45 in 2000–2001, and 42 in 2001–2002.

Chris Grenville shared the distinction with Justin Plamondon of being the only B.C. Icemen to perform at the Arena for five full years (1997–2002). Shown here celebrating one of the 172 goals that he scored during that period, Grenville had his best year in 2000–2001. In that season, he lit up the red light with 52 goals and added 57 assists for a terrific total of 109 points. The 2001–2002 campaign was his last at the Arena, and he ended it in style. Grenville tallied 52 points during the regular season and 8 more in the playoffs, before the B.C. Icemen faded into local hockey history.

# Six

# *Binghamton Senators 2002–2005*

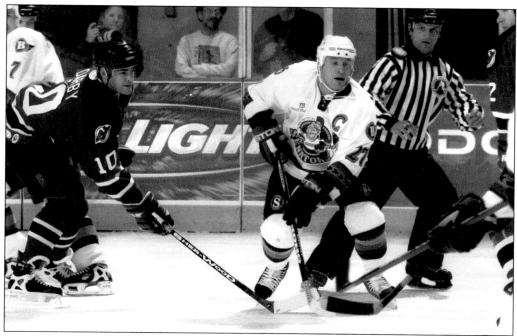

Steve Martins (center) battles Craig Darby of the Albany River Rats for the puck in this 2002–2003 action. As the team's first captain, Martins was on the ice for the B-Sens for 26 games and collected 16 points. Actually, it was Darby who had a day to remember that year. On March 2, 2003, against Bridgeport, he set the Albany record for assists in a game with five.

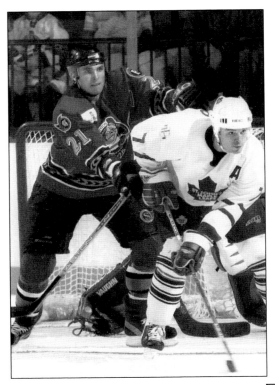

After 12 games in the NHL with the Ottawa club, Josh Langfeld, shown here battling for the puck, was back in Binghamton for 59 games during the 2002–2003 season. Langfeld starred in the playoffs with five goals and three assists, but his shining moment came when he scored the winning overtime goal against Worcester in the B-Sens' first-ever playoff game. Two of his other goals were also game winners.

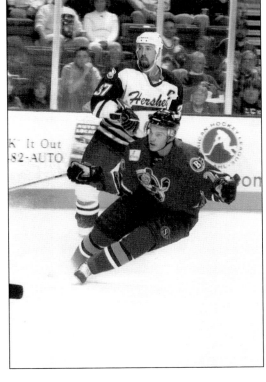

Antoine Vermette swoops past Brent Thompson of the Hershey Bears in this action from the 2002–2003 campaign. Vermette was the only B-Sens player to skate in all 94 games (including playoffs) that season, and what a year he had. As a first-year player in the AHL, Vermette amazed everyone by becoming an AHL All-Rookie forward and leading the B-Sens with 62 points, plus 9 assists in the playoffs.

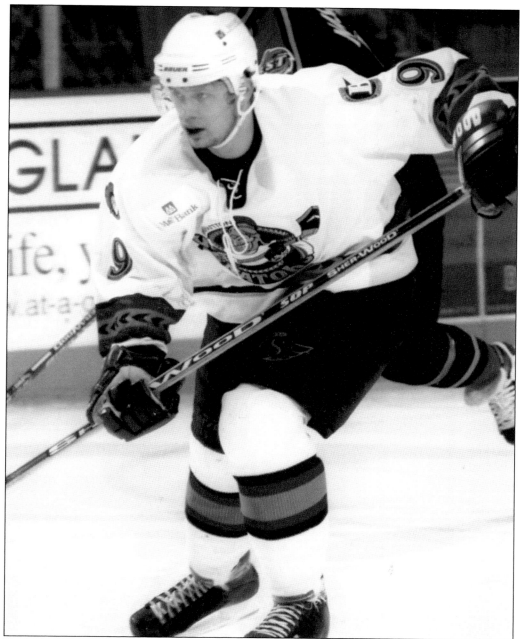

In every sport, and almost every year, one hears about a "can't miss" prospect. Some of these players justify the high expectations; most do not. Jason Spezza, Ottawa's first pick in the amateur draft and the No. 2 selection overall in 2001, was one of those "can't miss" prospects. In this case, the tag was deserved. In just half a season with the Binghamton Senators, in 2002–2003, the flashy center was so outstanding that he was brought up by Ottawa to the NHL for the remainder of the year. Due to the NHL lockout in 2004–2005, Spezza played with the B-Sens for the entire year. As might have been expected, he led the league in scoring (107 points) and assists (85), and was selected as the Most Valuable Player in the AHL for the season.

Born in Helsinki, Finland, Toni Dahlman was selected by Ottawa as a ninth-round pick in the 2001 NHL Entry Draft. He arrived in the AHL as a member of the Grand Rapids Griffins. Then the B-Sens were formed, and in their first year, Dahlman was at right wing for them, contributing 24 points in 59 appearances.

A teammate of Dahlman on that Grand Rapids club in 2001–2002, was Jeff Ulmer, also a right-winger. Both players arrived in Binghamton for the 2002–2003 season. The New York Rangers had signed Ulmer in 2000 and sent him to Hartford in the AHL for 48 games. He was subsequently traded to Ottawa. Ulmer had the distinction of scoring the first goal in B-Sens history.

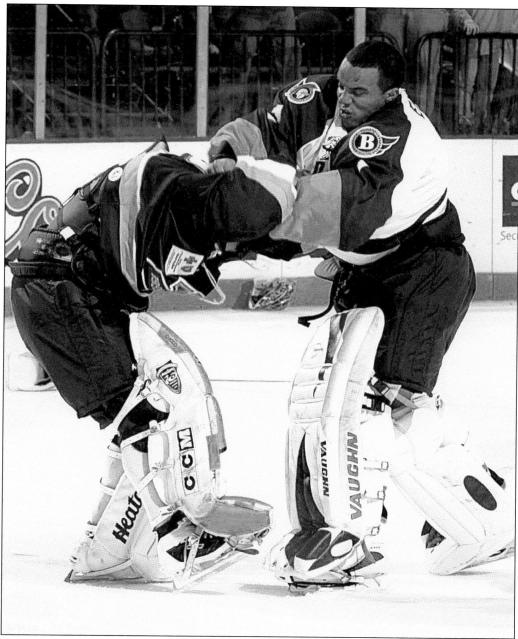

Ray Emery, shown here pulling up the jersey of Andy Chiodo prior to pummeling him, has confessed to enjoying the fighting aspect of hockey as much as the actual play. After three seasons with Sault Ste. Marie in the OHL, Emery came to the B-Sens as a 20-year-old in 2002. In 50 games, the budding superstar posted 7 shutouts and had a fine 2.42 goals against average. He won 8 of 14 playoff games that year and had 2 shutouts. Twelve days after being called up by Ottawa and winning his first NHL start by a 5-1 score over Atlanta, Emery was named to the AHL's all-rookie team.

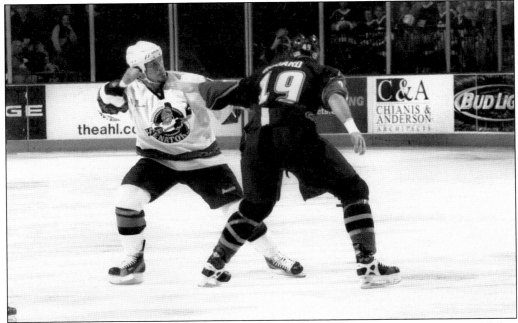

Dennis Bonvie joined the Binghamton Senators in 2002 and immediately set a team record that many thought would never be broken: he spent 311 minutes in the penalty box. If that sounds like a lot, consider that, as a Hamilton Bulldog in 1996–1997, Bonvie led the AHL with 522 penalty minutes. He is shown here in a familiar role, poised to level Bridgeport's Eric Goddard.

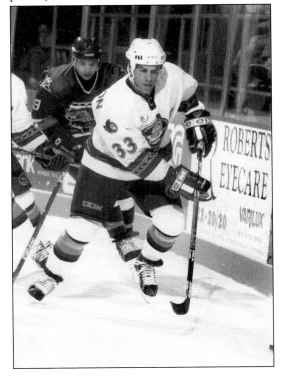

Like Dennis Bonvie, Dean Melanson hailed from Antigonish, Nova Scotia, and Melanson remembers frequent wrestling matches with Bonvie, aka "The Antigonish Antagonist." The two teamed up again in 2002–2003 with the B-Sens. Bonvie's toughness is well documented, but Melanson also had his moments. He tied a B-Sens record by accumulating 27 penalty minutes in a single game, on December 12, 2002. Bonvie must have been proud.

Alexandre Giroux was at center on one of the brand-new Binghamton Senators lines during their inaugural season in 2002–2003. He helped the club to gain its surprise division win that year, by contributing 19 goals and 16 assists in 67 games. Those 19 goals were fifth best on the team. Giroux's first professional season, 2001–2002, had been spent with the Grand Rapids club of the AHL, so he could well be proud of his performance in what was only his second season as a professional. His brother, Ollie, is a firefighter in Quebec City, Canada, and Alexandre has said that he hopes to become a firefighter, too, when his hockey career is over. Given the way that he is playing, firefighting may have to wait a long while.

Chris Bala, the left-handed-shooting left-winger from Alexandria, Virginia, got four years of competitive hockey under his belt at an institution not noted for that sport, Harvard University (1997–2001). Bala was Ottawa's second-round pick in the 1998 NHL Entry Draft. In 2002, he was with the B-Sens and tied Toni Dahlman with 24 points that season. Shown below, scooting over the ice in his own personal vehicle, is everyone's favorite lion cub, Maximus—more commonly known as Max. The Binghamton Senators' mascot is a huge crowd favorite. His favorite movie is reported to be *The Lion King*, and his favorite sports team is definitely the B-Sens. Max may not have gone to Harvard, but he knows how to keep the fans at the Arena excited with his well-known appeal for the team to "Go Sens Go!"

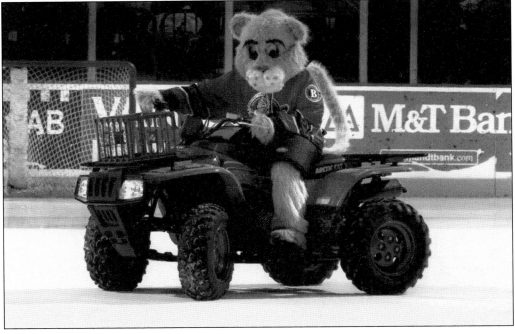

In 2002–2003, Brad "Shooter" Smyth, who had been one of the AHL's most prolific scorers as a member of the Hartford Wolf Pack, worked his magic for the Binghamton Senators. Besides tallying 56 points during the season, Smyth led the club in points in one game (4) and tied Antoine Vermette for most game-winning goals in a season (7). Smyth also led the club in the playoffs with 13 points.

From 1996 to 2000, B-Sens defenseman Brian Pothier honed his skills at Rensselaer College and was ready when the NHL's Atlanta Thrashers signed him as a free agent in March 2000. One year later, he won the Gary F. Longman Award as the top rookie in the IHL. Traded to Ottawa in June 2002, Pothier was on hand to score the dramatic game-winning overtime goal on opening night for the Binghamton Senators.

It takes muscle to be a defenseman, and at 6 feet tall and 205 pounds, Julien Vauclair fit the bill. By the 2001–2002 season, the native of Delemont, Switzerland, was skating in 71 contests for the AHL's Griffins, in addition to playing for Switzerland's Olympic team and its World Hockey Championship club. Vauclair must have been relieved when, in 2002–2003, he just had to knock down opposing players for only one team: the B-Sens.

After five seasons in the Western Hockey League (WHL), Greg Watson was traded from Florida to Ottawa in 2002. That was the same trade that brought goalie Billy Thompson to the Ottawa organization. In 2003, with the B-Sens, Watson got off to a fast start in October by tallying four points against Worcester in an 8-2 B-Sens win.

Goalie Billy Thompson is shown here filling out the medical questionnaire that is part of every player's entry physical. When people talk about a B-Sens goalie they usually have Ray Emery in mind, but Thompson has proven to be a rising star, too. By January 2005, he had a streak of 7 consecutive wins, a record of 12 wins against 5 losses, and a goals against average of only 2.61. Having two goalies who are both performing at a high level is a definite bonus for any hockey club. This combination of talent in the nets bodes well for the B-Sens in their quest for the Calder Cup in 2004–2005.

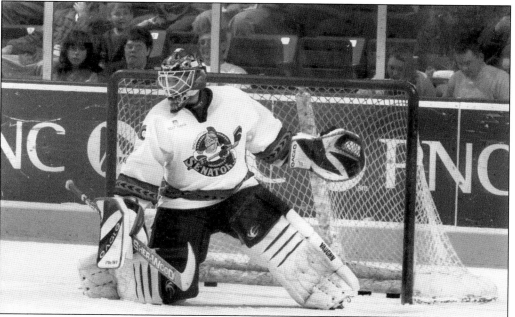

In the B-Sens' first year of operation, more than 40 players had taken to the ice at some point during that surprising run to the playoffs. One of the unsung heroes, among many, was Josef Boumedienne. Playing in only 26 games, he contributed 17 points, while spending only 62 minutes in the penalty box.

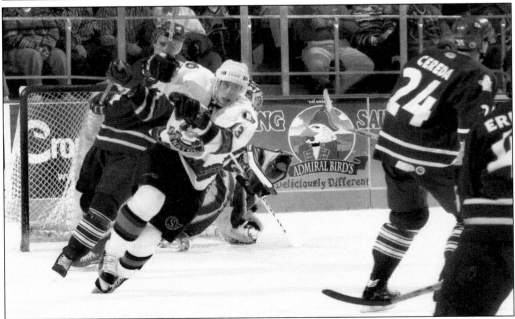

Pack ferocious desire into a 6-foot 3-inch, 209-pound frame and you have a dangerous weapon on the ice. Such was Christoph Schubert. Schubert was only 20 when he joined the B-Sens for their inaugural season. In 62 games, he had only 1 goal and 8 assists, but he threw his body around enough to accumulate 98 penalty minutes. His expression in this photograph speaks for itself.

David Hymovitz, shown here enjoying a moment with his daughter before the game, played a key role in the B-Sens' successful 2002–2003 campaign. He was on the ice for 76 contests, and contributed 15 goals and 19 assists. That placed him eighth on the team for most points scored that year.

The left-handed shooting Steve Martins, a Binghamton Senator in 2002–2003, played at Harvard University from 1991 to 1995. Not many go from the Ivy League to the NHL, but Martins did. He played in 23 games for the Hartford Whalers in 1995–1996 and spent the rest of the season with the AHL's Springfield Falcons. He had been picked fifth overall in the 1994 NHL Supplemental Draft by Hartford.

Toronto native Steve Bancroft came to Binghamton midway through the 2002–2003 campaign from Worcester. He was already in his 12th year as a professional, having started with Newmarket of the AHL in 1990. By 2002, Bancroft had played with Maine, Moncton, St. John's, Providence, Kentucky, Cleveland, and of course, Worcester. The left-handed shooter had 12 points in 29 games that year. In 2003–2004, he was on the ice for 77 games, adding vital veteran experience for the team. He also contributed 23 points in the B-Sens' stretch run to a playoff berth. His best year as a professional was 2000–2001, when he accumulated 50 assists and 20 goals for the AHL's Kentucky Thoroughblades.

Having a burly defenseman out on the ice to protect its speedy scorers is a must for any hockey team that hopes to be successful. The B-Sens have such a defenseman in Andy Hedlund. Now in his third year of keeping the other club's heavy hitters honest, he came to Binghamton in 2002 from Trenton of the ECHL. Hedlund is seen here beating Martin Cibak of Springfield to the puck.

After five years in the OHL with the Kitchener club (1995–2000), Serge Payer was assigned to Louisville of the AHL by Florida. His six points in five NHL appearances apparently did not impress the Florida brass, and Payer was traded to Ottawa in September 2003. With the B-Sens for the 2003–2004 campaign, the flashy center with the wicked left-handed shot responded with 91 points.

The camera catches B-Sens center Charlie Stephens about to be tripped by an opponent's stick in this AHL action. Stephens came to the B-Sens on January 23, 2004, in the trade that sent fan favorite Dennis Bonvie to Colorado. In just 37 games during that second half of the season, Stephens had 15 goals and 17 assists.

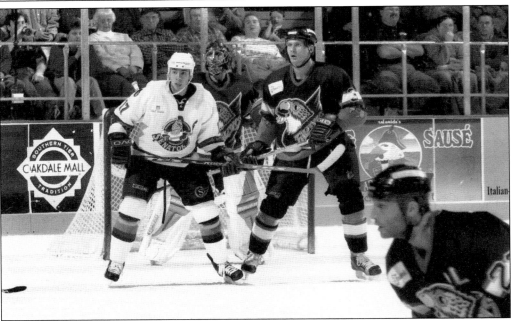

Chris Kelly's season with the newly formed B-Sens was a good one. In 77 games, he tallied 17 goals and 31 assists. In 2003–2004, Kelly followed that up with a total of 34 points. He was reaching his potential in the 2004–2005 campaign. By midseason, he had already accumulated his previous year's total of 34 points.

Jan Platil was born in Kladno, in the Czech Republic, but by age 17 the talented youngster, who could score as well as play defense, was in Canada suiting up for the Barrie club of the OHL. With the B-Sens in 2003–2004, Platil is shown here "gently" nudging Bridgeport's Eric Manlow out of the play. Luckily, the linesmen were looking elsewhere.

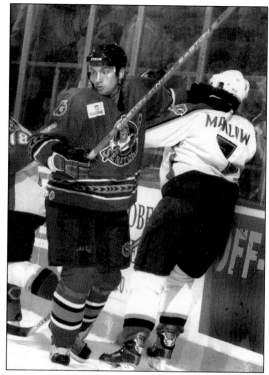

Arpad Mihaly was born in Miercuria, Romania, in June 1980. By age 19, he was skating for Sioux City in the United States Hockey League (USHL). After stops at New Haven, Mohawk Valley, Philadelphia, and Wheeling, Mihaly arrived in Binghamton in the fall of 2003. Still here at midseason of 2005, playing left wing, he had appeared in 26 games and had 2 goals and 1 assist to his credit.

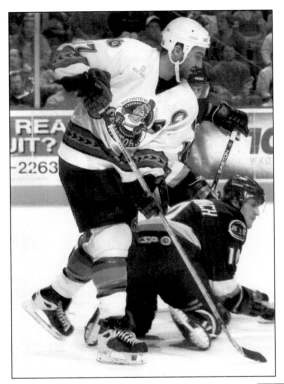

After scoring 100 points as a junior with Chicoutimi of the Quebec Major Junior Hockey League (QMJHL) in 1996–1997, Denis Hamel was playing in the AHL with Rochester at age 20. Ottawa signed him as a free agent in July 2003 and assigned him to the B-Sens. Hamel thrived in Binghamton. In 2003–2004, he led the team in goals (29), assists (37), and total points (66). It was no surprise when he was named to the AHL All-Star first team.

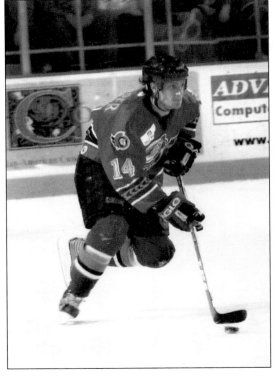

Brad Tapper was traded to Ottawa from Atlanta in 2003–2004. Sent immediately to the B-Sens, and despite a concussion incurred in February, Tapper collected 9 goals and 12 assists. A highlight of his career occurred back in his days at Rensselaer Polytechnic Institute, when he led the entire nation in game-winning goals (7!) during 1999–2000.

The B-Sens' Jody Hull (left) battles for the puck with Benoit Gratton. After splitting time with the Hartford Whalers and the Binghamton Whalers in 1989–1990, Hull was traded to New York in July 1990. As a Binghamton Ranger in 1991–1992, he tallied 65 points. Twelve years later, Hull returned to the Arena as a B-Sens player-coach, making him the first player ever to skate for three different Binghamton AHL franchises.

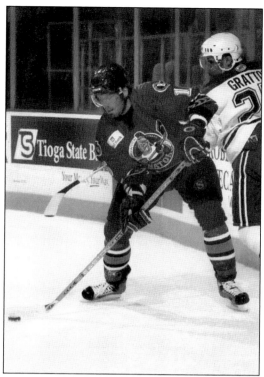

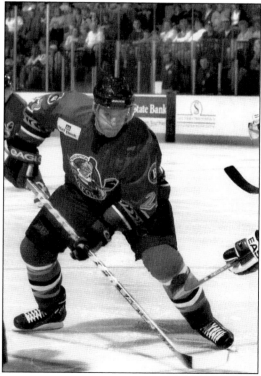

By age 17, Brooks Laich was already a full-time center for the Moose Jaw Warriors of the WHL. The following year (2001–2002), he was traded at midseason to the Seattle Thunderbirds. Laich caught the attention of the Ottawa Senators when he tallied 94 points for the Thunderbirds in only 60 games. He was with the B-Sens in 2003–2004, and already had 33 points when he was called up to the NHL.

Scott Allegrino began as a self-proclaimed "rink rat" and now serves as the B-Sens equipment manager. He provides the vital service of tending to the needs of the players for their "tools of the trade." Allegrino is shown here sharpening skates for a player. If not for the NHL lockout in 2004–2005, he would have been tending to the needs of the Ottawa Senators.

Everyone agrees that hockey is a rough sport. The ice is hard and opponents' elbows and skates are sharp. Every team needs a skilled trainer to handle the constant aches, sprains, and bruises that are a natural aftermath of every game. The B-Sens are fortunate to have one of the best in Dom Nicoletta, shown here putting his degree in kinesiology to good use on Antoine Vermette.

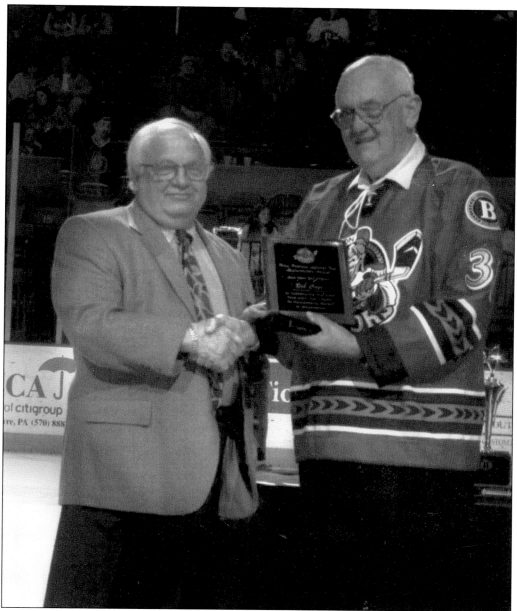

It was far more than the usual fan-appreciation gesture when B-Sens part-owner Bob Carr (left), presented a plaque to Hans Petersen. The undisputed No. 1 fan of hockey in this area, Petersen became "Chicken Man" to local fans toward the end of that first season, 1973–1974, when he taunted opposing teams by dangling a rubber chicken at them over the glass. He has come up with other innovative messages to motivate the new home teams that have since arrived in the area. That remains true right up to the present B-Sens games, where he recently unrolled a scroll that said, "Ref, what time do you want your wake up call?" Petersen does more than liven up the games. His beautifully arranged and framed photographs of the teams that have played in Binghamton adorn the administrative offices, and are just another example of his unique involvement in local hockey.

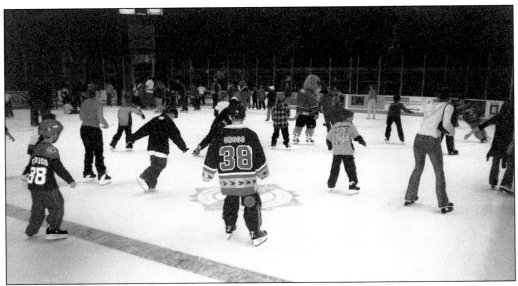

What could be better, after watching an exciting game at the Arena, than putting on your skates and going out on the ice? These fans are shown doing just that after a November game in 2003. The youngsters seen below are enjoying another of the Binghamton Senators many promotions—a skate-around birthday party. What a memory for the birthday boy, Shaun McCann. From left to right are Shaun McCann, Kevin Clarke, Patrick Greenman, Tyler Gunn, and Ian McCann.

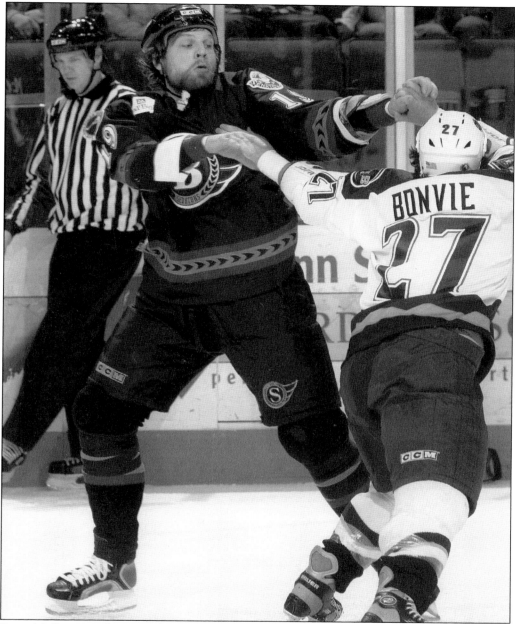

Brian McGrattan, always ready to take off the gloves and duke it out with anyone and everyone, spent 173 minutes in the penalty box in 2002–2003. The following year, he led the league in penalty minutes with 327, and in 2004–2005 he fought his way to a new AHL record of 551 minutes. McGrattan is clearly a protégé of Dennis Bonvie, the former Binghamton Senator and previous record holder for penalty minutes in a season, who is now battling for the Hershey Bears. In this classic 2005 photograph, McGrattan and his former mentor meet again on the ice and greet each other in appropriate fashion.

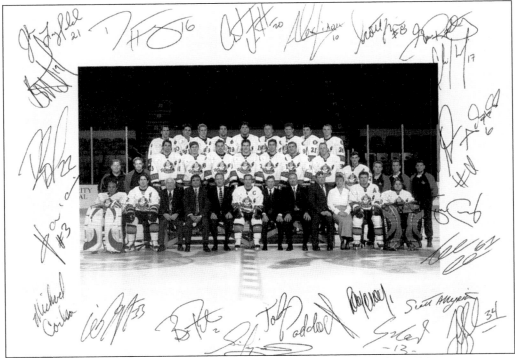

The 2002–2003 season was the first for the Binghamton Senators and they showed their appreciation for their enthusiastic fans by issuing this Christmas card. The autographs, in addition to the team picture, certainly added to this fine piece of memorabilia. The coach was John Paddock, who reached a milestone during the 2004–2005 season when he earned his 500th victory.

Gathered here is memorabilia from more than three decades of great hockey at the Arena. These pieces from the collections of Andrew Strong and Ken Wilson Jr. include pucks, skates, and jerseys from the Dusters, Whalers, Rangers, Icemen, and Senators. Chris Kelly's helmet, Brian McGrattan's jersey, and Billy Thompson's blocker and glove are all clearly visible. Sticks from Whalers and Dusters promotions are also included.